My work is about the transformation of the landscape.

My interest is in the boundaries —
the lines of tension —
between the environment
and the construction of culture.

JOE DEAL

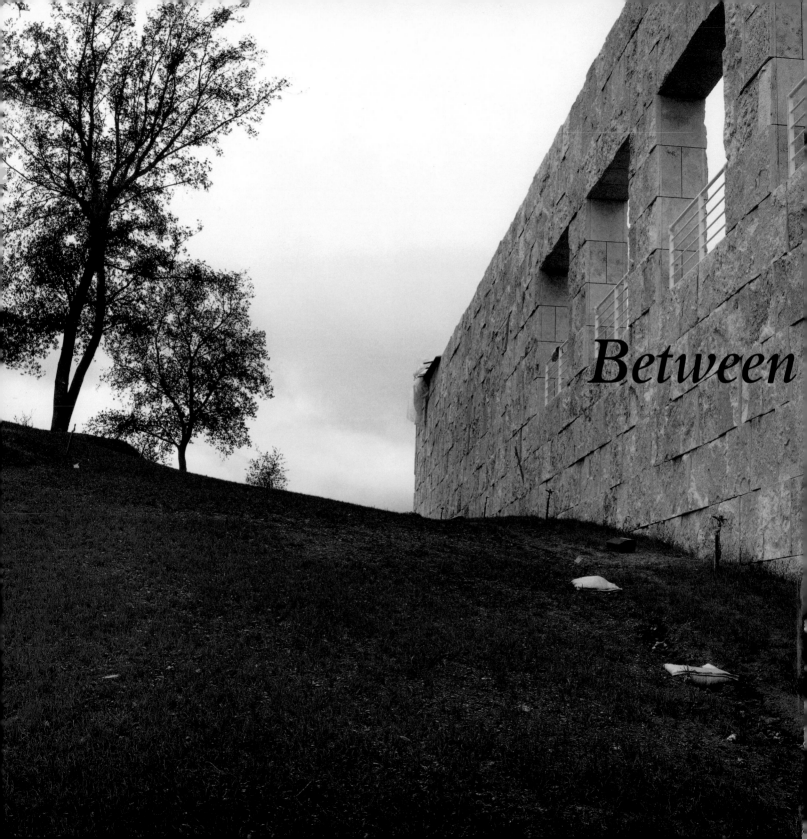

Between

Joe Deal

Mark Johnstone

Richard Meier

Weston Naef

Nature and Culture

Photographs of the Getty Center by Joe Deal

The J. Paul Getty Museum

LOS ANGELES

The *Topos* portfolio by Joe Deal is part of
the collection of the Getty Research Institute
for the Arts and the Humanities.

Excerpts from Thomas Pynchon, *Mason &
Dixon* (New York: Henry Holt & Company,
Inc., 1997) and Wallace Stegner, *Where
the Bluebird Sings to the Lemonade Springs*
(New York: Random House, 1992) gratefully
acknowledged.

© 1999 The J. Paul Getty Museum
1200 Getty Center Drive
Suite 1000
Los Angeles, California 90049-1687
www.getty.edu/publications

Christopher Hudson, *Publisher*
Mark Greenberg, *Managing Editor*

PROJECT STAFF

Gloria Gerace, *Editor*
Shelly Kale, *Manuscript Editor*
Jeffrey Cohen, *Designer*
Suzanne Petralli Meilleur, *Production Coordinator*
Irene Lotspeich-Phillips, *Collections Registrar,
 Getty Research Institute for the Arts and the
 Humanities*

Printed by Gardner Lithograph
Buena Park, California
Bound by Roswell Bookbinding
Phoenix, Arizona

Front cover, August 1997, looking south
(G12.10.97)
Back cover, December 1994, looking north
(G11.13.94)
Title page, December 1996, looking west,
Research Institute (G26.4.96)

Library of Congress
Cataloging-in-Publication Data

Deal, Joe, 1947–
 Between nature and culture : photographs
of the Getty Center / by Joe Deal.
 p. cm.
 ISBN 0-89236-549-8
 1. Architectural photography—
California—Los Angeles. 2. Getty Center
(Los Angeles, Calif.)—Pictorial works.
3. Art centers—California—Los Angeles—
Design and construction—Pictorial
works. 4. Museum buildings—California—
Los Angeles—Design and construction—
Pictorial works. 5. Building sites—
California—Los Angeles—Pictorial works.
6. Los Angeles (Calif.)—Buildings, structures,
etc.—Pictorial works. I. Deal, Joe, 1947–
II. J. Paul Getty Museum. III. Title.
TR659.D474 1999
779'.4794'94—dc21 99-12089
 CIP

Contents

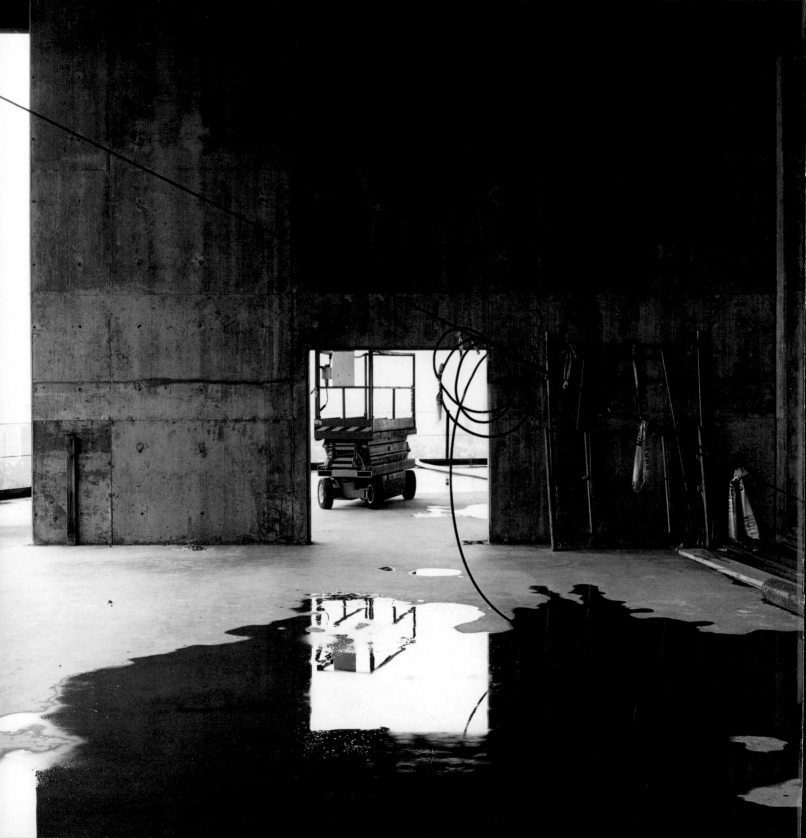

Preface

Richard Meier

As architect of the Getty Center, I was fortunate to have lived on the site for almost eleven years. This gave me the opportunity to come to know the site better than any I had ever worked on. I would regularly walk the small paths that crisscrossed the 110-acre site in the early morning, and rather than take along a sketchbook, which was difficult due to the rugged terrain, I would bring a camera with me. Documenting the changing topography, the incredible views, and the emerging construction in this way was an important part of the design process for me. Just as my photographs represent my personal view of the site, Joe Deal's work expresses his personal interpretation of the transformed landscape.

This book contains a selection of photographs drawn from a portfolio created by Joe Deal of both the site and the construction process of the Getty Center. The construction photographs provide us with an intimate view of what is normally a very private domain. Usually, construction is only experienced by a relatively limited number of people who are directly related to the building process—architects, engineers, contractors, clients. Through these photographs Deal has given all of us a glimpse of this private world and has frozen this world in time, capturing an otherwise fleeting moment of process. The buildings will never appear in this state again. In direct contrast to the finished buildings, which embody the art of permanence, Deal has preserved the buildings in an impermanent stage.

In his photographs, Deal gives us the beauty of hidden spaces. We experience the beauty of materiality, of just-poured concrete, of exposed beams. We see the skeleton of shapes that are now so familiar. There is a richness to the images as they convey both a sense of creation and one of decay. Taken as single images, particularly the interior spaces could be mistaken for abandoned rather than newly constructed buildings. There is an intentional absence of the human presence in the images. Workers are seen only as small forms in the distance taking second place to the forms they are creating. Deal is not trying to document the process or mechanics of construction, but rather the beauty of the forms, the sense of scale, the magnitude of the undertaking.

Deal's photographs are full of juxtapositions and contradictions. In one image we see a tall crane, centered in the picture, filling the entire height of the frame with the skyscrapers of downtown Los Angeles in the distant horizon. The verticality of the crane is emphasized and appears almost as if it is the construction rather than the constructor. There is a richness to these contradictions that gives the photographs so much fullness and depth. Deal's exquisite interpretation of the building of the Getty Center has forever enriched our appreciation and understanding of this unique place.

Richard Meier is one of America's foremost architects. In addition to the Getty Center, he has designed museums and other public buildings throughout the world.

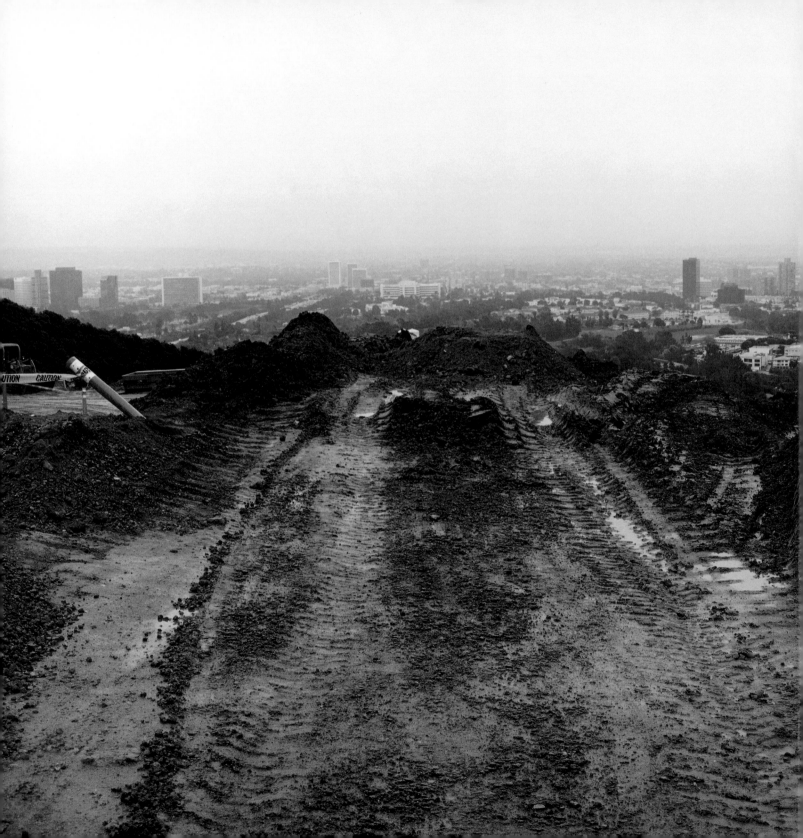

Stopping Time

A PHOTOGRAPHER'S CHANGING VIEWPOINT

Weston Naef

WHEN IN EARLY 1984 Joe Deal accepted the assignment of recording the building of the future Getty Center, all he knew for certain was that over the next few years the site would be transformed from its native condition. The architectural firm had not yet been selected nor had the requirements for the building program been established. Deal's chosen medium of expression—the photograph—could not be surpassed, because the power of photography is to capture time more vividly than any other visual medium.

Sequences of photographs inevitably record how things change and how they stay the same, making the camera a powerful documentary tool. Such sequences, made over several years, also show the evolution of the photographer's viewpoint, as well as its consistencies and development. Through these photographs we can see how the artist starts with a subject familiar to him—an undeveloped landscape existing at the boundary of a developed area—and then progresses to an unfamiliar subject—the process of creating architecture.

Deal's ostensible subject in the photographs reproduced here is the site of the Getty Center, a tract of land located in the Brentwood district on the western edge of Los Angeles, which he recorded between April 1984 and March 1989. In a second campaign of photography, which he undertook between April 1992 and August 1997, when the construction was nearly completed, he documented and interpreted how the structures themselves took shape.

When hired in 1984, Deal was a professor of art at the University of California at Riverside. A few years earlier he had earned a Master of Fine Arts degree in photography and was strongly associated with a style of picture-making first defined by the exhibition New Topographics, which he had helped organize for the George Eastman House in Rochester, New York, in 1975, and which lent its name to a new school of photography. Presented together for the first time were the works of Deal, Robert Adams, Lewis Baltz, Bernd and Hilla Becher, Frank Gohlke, Nicholas Nixon, Stephen Shore, and Henry Wessel—artists who

FIGURE I

Carleton E. Watkins or George Davidson
*Looking across the Santa Monica Mountains
to the San Gabriels,* 1889
Albumen print, 7 × 9¾ in.
(18 × 24.3 cm), 88.XM.92.26

shared a concern for the formal properties of the built environment and in whose photographs the inhabitants were left mostly unpictured.

In 1997, when Deal finished the Getty Center project, he was a different person than when it began thirteen years earlier, and he saw the world with a different pair of eyes. He had accepted an administrative position at Washington University's art school in 1989 and had relocated to St. Louis, Missouri, where he made the transition from an artist and instructor in the theory and practice of photography to a manager of people and an administrator at a school of art within a large urban university.

Many of Deal's Southern California photographs showed how the landscape was transformed from chaparral-covered terrain to residential enclaves. His images quietly but subversively raised questions about land and water use, along with other environmental and cultural concerns. He walked, stylistically and literally, in the footsteps of Carleton E. Watkins, the pioneer California photographer active a century earlier.

When Watkins visited Los Angeles in 1889, it was an empty plain surrounded by hills and mountains. Figure 1 is the earliest photograph that was made looking toward the Getty Center site. One of Watkins's favorite compositional strategies was to establish a dominant

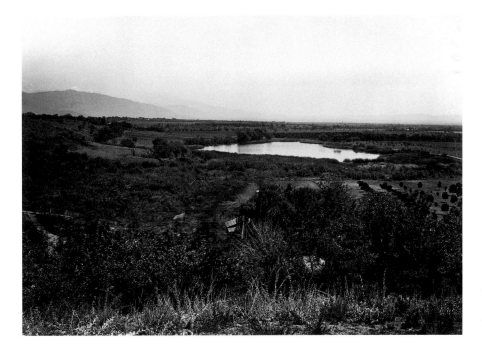

FIGURE 2

Carleton E. Watkins
(American, 1829–1916)
*View in San Gabriel Valley, Los Angeles
County,* 1884
Albumen silver print, 14½ × 20½ in.
(36.83 × 52.07 cm), 98.XM.159.1

foreground—often consisting of repeated, random natural forms—against which the middle and background are juxtaposed (Fig. 2). Deal follows a similar strategy of setting the context for his location by playing the foreground against the background (page 28, *left*).

In one of his first photographs at the Getty Center site in 1984 (page 76, *bottom*), Deal looks through a tangle of bushes toward the most prominent neighboring property facing east—the circular form and postage-sized lot of the Holiday Inn hotel, located at the intersection of Sunset Boulevard and Church Lane near the southeast corner of the 700-acre Getty property. Few people have observed how frequently in Los Angeles wildness abuts civilization. Deal's photograph establishes the primitive simplicity of the Getty site with reference to nearby residential and commercial real estate development. The picture was made with apparent objectivity and detachment, but embedded in it is the sly editorial comment: Why change this scene? In 1984 and 1985—prior to its construction—Deal had the Getty Center site pretty much to himself, and this perhaps contributes to the solitary mood expressed in the photograph.

In another image, taken in 1984, Deal gazes through the chaparral at the existing private residences built on property adjoining the western edge of the Getty site (page 74). He looks down at the houses with apparent objectivity, but implied in the photograph is the ques-

tion: What will the inhabitants see when they look up here after the Getty Center is built? Social relevance expressed in the vocabulary of visual formalism is an idea at the heart of the New Topographics school of photography.

In 1986, the process of real change began to occur at the site as construction started on the main vehicular artery, which was carved into the northeast hillside. Deal's subject had begun to evolve from a natural environment to one shaped by human intervention, and he was now required to adapt his perspective to this new condition. Moreover, he was no longer a solitary outsider observing the forces of nature and recording in his pictures minuscule changes in vegetation, soil erosion, and what have you. Rather, he became a privileged insider, a witness to the first actions on the site that forever changed its appearance and its relation to the surrounding terrain. Deal chose a viewpoint (page 51) from which the powerful forms of the carved earth with its concrete embankment recall a sculpture. The light is soft and indirect so as to suggest the romance of dawn or dusk. We are invited to see beauty, not despair, in the dry but inevitably violent process of shaping the earth.

Although the construction of buildings had not yet begun, by 1987 and 1988 the site showed more signs of human intervention (page 43, *bottom*). In a visit to the site in 1987, Deal met a geologist whose job was also to observe the land but whose purpose was very different from his own. Deal was fascinated by the geologist's work and his process of analyzing what lay below the earth's surface. Although the geologist himself does not appear in Deal's photographs, the circumstantial traces of his presence exist in the forms of an excavated hillside and the ladder he used to get himself closer to his subject (page 14).

During 1989, as Deal began a new job at Washington University, he also continued work on a series of photographs very different from those of the Getty Center site: a self-assigned series of carefully posed color portraits of friends with accouterments that helped to define them. The genre of portraiture, whether in painting or photography, is considered diametrically opposite to that of landscape, the subject that had occupied Deal's attention for more than a decade; color is equally different from black and white. His Southern California landscapes were rarely populated by human figures; however, in a dramatic change of approach, he began to focus on people—not those who were actually at work or play, as they seemed to be in his pictures, but rather figures posed in the process of activities that defined their lives.

The summer of 1989 saw the conclusion of phase one of Deal's work at the Getty Center. He next returned to the site in 1992, curious about progress on the building project. Not surprisingly, he was a somewhat different photographer than he was four or five years earlier. An exhibition of his contextual portraits had been installed in the projects gallery of the Saint Louis Art Museum, and he no longer had the particular environment of Southern California to influence his perspective.

The pictures taken in 1992 show how the earth was penetrated to establish the foundations necessary to stabilize and support the structures that would be built above and around them. Never content to show just surfaces, Deal took advantage of the opportunity to look below the skin. He wanted his Getty Center photographs to reflect something deeper than just the lay of the land, some suggested social or cultural messages, as in his photograph of a hole in the ground that was created for the seven-story underground parking structure—a building that would be experienced only as an interior space (page 83).

In his new images of the Getty Center site, Deal returned to themes suggested by his contact with the geologist and looked again at symbols of what was below the earth's surface. He was attracted to boulders that had been excavated during the move of thousands of cubic feet of earth from one part of the site to another (page 48, *right*). As the result of an agreement between the Getty and the city of Los Angeles, not one teacup of dirt was allowed to leave the property. Deal was fascinated with how the dirt was moved continuously from one place to another, each time creating a hill that previously had not existed. Always the subversive, Deal asks the question through the photograph: What will eventually happen to this displaced artifact of nature?

Deal, who does not really consider himself an architectural photographer, was faced with a new challenge in photographing the construction process. Although he had accepted the invitation to begin a second campaign of photography at the site, he did so with the understanding that his series of photographs would end before the construction was fully completed.

In 1993, Deal photographed the skeleton of the buildings—the concrete foundations, the steel framework that supports the interior and exterior walls, the wood forms that would soon be filled with concrete—all of which normally are seen only by the builders and architects, and which are ultimately covered by various types of surfacing materials. Deal was very much drawn to the initial parts of the construction process that signaled the creation of floors,

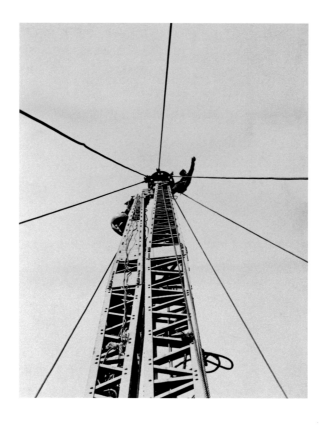

walls, and ceilings. In recording them (pages 82–113), he was literally stopping time on an irreversible process of construction.

If the photographs taken during Deal's 1984–89 campaign reflect the influences of nineteenth-century photographers Carleton Watkins, Timothy O'Sullivan, Alexander Gardner, and A. J. Russell, those taken during the 1992–97 campaign—in which workers seen in their context become an important element—most closely recall Lewis W. Hine's 1930 Empire State Building series. Deal's picture showing the silhouette of a worker on scaffolding against the landscape (page 63) evokes Hine's silhouette of a worker on the Empire State Building (Fig. 3). However, Deal never made portraits of workers as Hine had, but rather always subordinated the people to their physical context.

During 1994 and 1995, light, the pattern of architectural elements, and the symbolism of the building materials became Deal's subjects. He was endlessly fascinated with the process

by which the architecture emerged first as a sequence of solid forms that were created with voids left for doors and windows. Several pictures record the light falling through these spaces before their functional destiny had been realized. As detached as his perspective usually was, Deal found himself seduced by the romance of light reflecting off a puddle of water as it passed through an emptiness that later would become a fireplace for the decorative arts galleries (opposite Preface).

By 1996 and 1997, the construction process had already passed the point at which the skeleton was being covered by its permanent surfaces. Deal then focused on the process of sheathing the interiors with enormous sheets of gypsum board whose joints and nail holes were covered with spackle, leaving painterly patterns of gray and white (page 31, *left*). He was continuously adapting his vision to changes in the subject.

Deal surprised us and maybe even himself by falling in love with the travertine stone that covers many of the exterior surfaces (page 123). Unlike almost everything else that Deal photographed on the Getty Center site, the stone has less a structural function than a decorative and protective one. Nevertheless, Deal saw in the stone deeper social and cultural symbolism: As a sedimentary rock, the travertine once formed the floor of an ancient terrain covered by water, and as such is the matrix for ancient living things that are preserved in the form of fossils—providing a new metaphorical landscape.

As the construction came to an end, Deal concluded his second series of photographs by returning to some of the strategies that had guided him in the first phase. He sought out vantage points from which he could look beyond the internal structures to the unchanging motifs in the distance that had been his earlier beacons (page 73).

"My work is about the transformation of the landscape," Deal has said. "My interest is in the boundaries—the lines of tension—between the environment and the construction of culture." We understand this fully only by standing where Deal stood on the Getty Center site and by absorbing the interpretive power of his intelligently made still photographs. We marvel at the way these photographs reveal the growth and change in the artist's perspective as well as record the transformation of the site. We become abundantly aware that a photograph can never be fully objective, but is always an expression guided by the artist's thought and perception.

Weston Naef is curator of the Department of Photographs of the J. Paul Getty Museum.

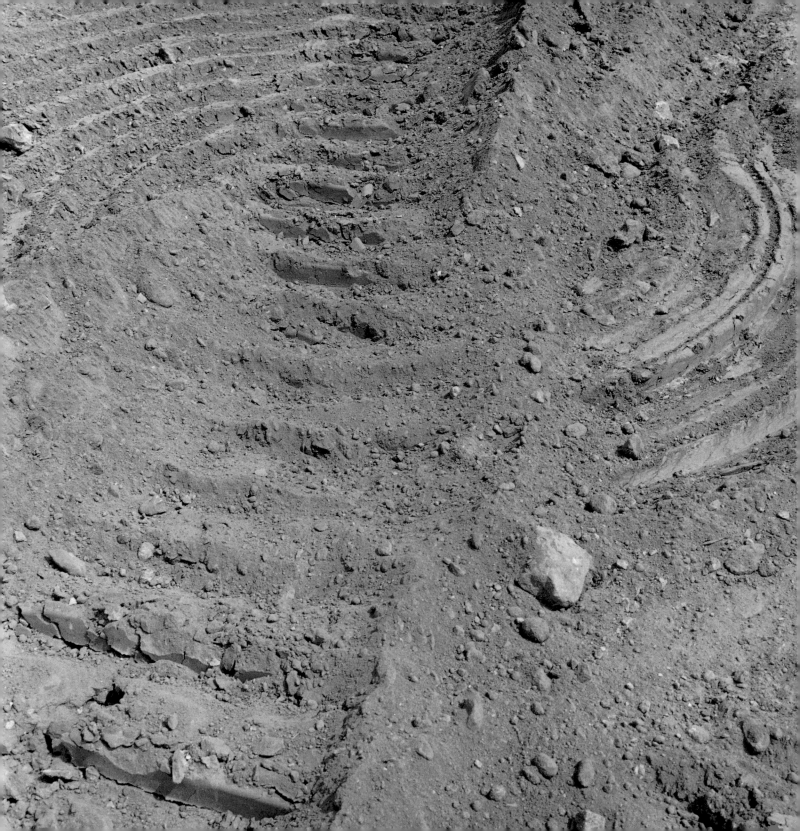

The Construction of Culture

Mark Johnstone

ATOPOGRAPHICAL MAP DEPICTS the natural and man-made features of a site to illustrate their relative positions and elevations. Maps are always interpretive and provide a perspective based on the type of information gathered and conveyed. They can describe physical characteristics (the sewer system) or more abstract data (demographic distribution of wealth). A map is designed to show relationships of specific information and its usefulness is determined by the user's point of reference. A map of the electrical power grid in metropolitan Los Angeles has little relevance for the person seeking the best bus route to San Diego. A map is a limited description of a place that can be located only as a particular site.

The photographs in the portfolio, *Topos,* by Joe Deal are a map—or maps—of the site and construction of the Getty Center. A series of questions circulates around their examination: What constitutes the "natural" landscape? Is it the flora and foliage, even though much of the fauna has disappeared? Is it the state and condition of a place after an earthquake, fire, drought, or flood? What remains of a place when observable parts are dislocated? Is there a hierarchy of importance to grass, gravel, bushes, boulders, trees, and hills? What constitutes "construction"? Is it the whole process, and if so, when does it end? When do the layers of work coincide with the thought and purpose of the architecture? Is it when the building surfaces are added, when support services are connected, or when people begin using it? If Deal's photographs are a form of mapping, what do these images tell us and what are they about?

We seek to identify and know more about a place, beyond description, in order to understand something more of how it affects us. A place is mapped to better know it, and it is named to reflect our feelings about it. In one way, Deal's portfolio, *Topos,* could be described as a kind of archaeological map of the Getty Center's construction. A technical definition of archaeology is the study of material remains and past human activities, but archaeology is *about* the identification of cultural interactions and relationships.

The opportunities provided by the land in Los Angeles are defined by the limits of a semi-arid desert. There are no natural water supply, harbor, or known mining opportunities, and the few pockets of oil have been pumped out over the last eighty years. The agricultural or recreational opportunities that once existed have been replaced principally by buildings and concrete transportation routes. The common business thoroughfare is a polyglot of cars, sidewalks, and streets lined with storefronts, and any given block is likely to be two-thirds occupied with at least one of the following enterprises: video rental, Vietnamese food, donuts, flowers, hair and fingernail salon, copy/fax/private mailboxes, storefront ministry or psychic or palm reader, coffee, and furniture for rent. The daily currents of the city seethe in these blocks. The purposes and opportunities provided by the Getty Center are not part of this strip.

The Getty Center is located at the foothills of the Santa Monica Mountains, a relatively undeveloped mountain range that bisects the Los Angeles metropolitan area. In late spring and early summer the natural foliage of this region takes on the appearance of the mottled brown-and-green camouflage landscaping used by model railroad builders. In his earliest forays onto the site, Deal set a pace that he maintained throughout the project. It is a way of looking—dictated by wading through scruffy chaparral, with no apparent goal in sight—that systematically considers every compass direction.

Deal's first photographs acknowledge the striking quality of light that falls on the site. Lines of branching chaparral glow as if drawn with a white, hot pencil. The light is so bright, so crystalline, that parts of the scrub brush appear to emanate light, as if they were electrified or fabricated for a science fiction/Western movie set. Surveyors' flags appear, the brush is cleared, and an unseen army of backhoes or bulldozers dislodge multiple strata from below the earth's surface (page 44).

This grand-scale movement of the earth is made more somber with infrequent dramatic shadows. Various strata are apparent in the dirt, some of it black, some a rich, deep gray, and the remainder a light gray dust that is ever present throughout the California southland. Seven hundred and fifty thousand cubic yards of earth were moved at the site as part of a massive mountain face-lift, and Deal's images of crumbled earth piled to the side of areas scraped smooth are microcosmic dioramas of how the North American plains and mountains have been resculpted by human intervention. There is an inescapable legacy of western land use, representing an escape from civilization and the imposition of civilization upon it. The site is pic-

tured as a large, empty space, undifferentiated in apparent direction or intended purpose. But that absence is not an emptiness of opportunity or lack of beauty. It is simply a presence of that space endemic to the North American West.

The fourteen-year period during which Deal lived and worked in Los Angeles corresponds to the period of this photographic project, although the two do not perfectly coincide. In his portfolio *Buena Vista* (1974–76), which includes photographs from other western states and was completed upon his arrival to the Los Angeles region, there are long visual approaches between the camera's position and any evidence of human activity in the landscape. By 1990, Deal's expeditions, which often produced single images, had been principally replaced with a series of images made over a period of time, as in *Site Documents* (1985–86), a commissioned portfolio about the construction of The Museum of Contemporary Art in Los Angeles. In some ways, this process of discovery, moving from a distant viewpoint to observations of surface relationships, was inverted in *Topos*. The earliest pictures observe minute features of the landscape, and the final image is a distant view of the completed buildings "inwards" from the edge of the site toward its new center.

There are striking parallels between Deal's other series of works and *Topos*. *Carbon Canyon* (1981–83), a studied appreciation of canyon trees and underbrush that were blackened and destroyed by fire, can be read as a learning ground for Deal's earliest views at the Getty Center site. *Diamond Bar* (1980–81) is a series of observations on the delineation of personalized space. *Subdividing the Inland Basin* (1983–89) charts the wholesale transformation of vast tracts into rows of subdivision developments. People are either absent or occupy an impersonal middle distance throughout these series, but they are made the subject of *Men and Women* (1988–91), with an appreciation of the mysterious qualities and wonderment that give definition and purpose to being human. This movement toward the implication of relationships and personal identity in Deal's previous series is characterized in *Topos* by the nexus of architecture and construction as a human process in the evolution of civilization/culture.

Surprisingly little appears of the hundreds of workers who dutifully tended this site. Whether dwarfed by a crane or intent on welding, they are a testament to the industrialized beauty of labor and materials, a counterpoint to the early-twentieth-century photographs by Lewis W. Hine and the modern sculpture of Richard Serra. Manual-labor implements such as buckets or sawhorses are reminders that these are scenes of work, and that this is a site im-

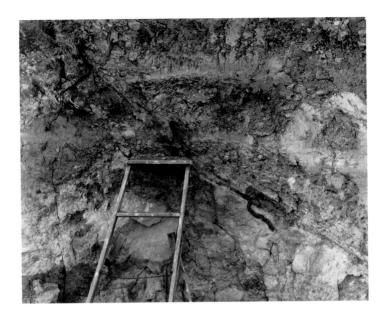

mersed in a process of change. Stairways and ladders are frequently used as devices to indicate levels and as measuring sticks for scale (above; page 15). Detritus and the waste by-products of the construction process are largely ignored, for the *act* of construction is both the object and subject of *Topos*.

In Deal's photographs, foundations are laid, steelwork is sprayed with fire retardant, and building elements spring into view with curving spans of concrete. Gardens are laid out along with the building footprints, with a planned replanting that denies the heritage of this particular area but is as common as the flora of nearby hillsides where immigrant flora has already been introduced to the indigenous plant life. (Herein exists a good example of the quandary about what is "natural" about a landscape. The introduction of new plant species can be a beneficial activity, helping to control soil erosion. It can also be a Faustian transaction that introduces new diseases or pests, overwhelms native fauna and flora, and contributes to the erasure of local identity.) The bright light that permeates the site imbues the dark linear and geometric forms of steel and scaffolding with a gestural, expressionistic air. Spidery webs of rebar blossom amidst a framework of solid steel beams, as the filigree grids of reinforcing rods and forms that will define the walls are put in place. In later images these sketched forms are spatially given flesh with masses of poured concrete.

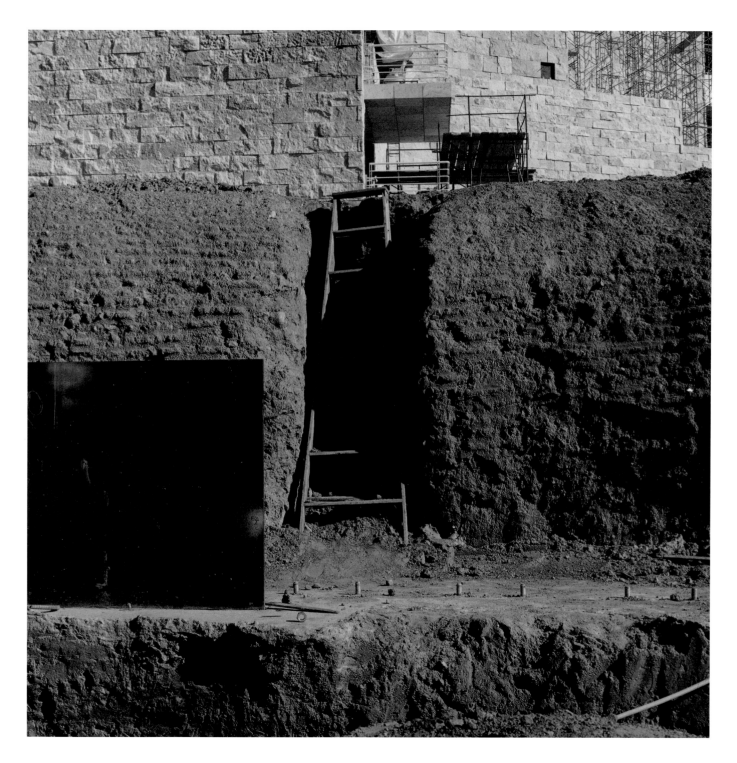

The photographs in the group *Occasion* (pages 82–113) show architectural constructs that will disappear when the walls and exterior surfaces have been added and express the building as a visual and physical mediation of the background. A bare concrete floor is an equivalent tone to previously raked earth. The linear architectural elements visually reorganize a background landscape into rectangular views, which are further modified by veils of plastic sheeting. The actions that took place *in* the landscape are more concentrated in the progression of the building assemblage. Where Deal approached the earliest stages of building from a distance, he moves in and creates a more human scale that contrasts the scope of activities with the landscape *out there*. Edges of sky space appear in the corners or top of many of these views. Only when he moves into the completed interiors, where powdery gypsum dusts surfaces in the way that dust particulate settles throughout the landscape, does the landscape disappear.

The contour lines of a topographical map indicate different elevations, or levels, at the site. These levels are both metaphorically implied and physically manifest in Deal's photographs. An interchange is described through the mixing of natural resources and unknown institutional potential. There is taking from the "disorder" of nature, and the giving back of an imposed order. A larger, imaginary map might indicate the relationships between this construction and other buildings designed by Richard Meier & Partners, or between the (future) activities of the Getty and Los Angeles, or between the art world and the world at large. This is echoed in Deal's attention to a recurring formal motif of concentric circles (page 10). Appearing in the graded tracks on the earth, puddles from rainwater, coils of wire cable, and as part of Meier's overall Aristotelian design, the concentric circles are like the ripples emanating from a drop of water. They are momentary and encompass changing areas. They provide an underlying rhythm, from being the basis for Robert Irwin's garden to the internal order that informs Meier's design. It is an implied acknowledgement of place-making, based both on what is present and what later will be added.

Two other physical characteristics of Los Angeles are emphatically present in this particular location. There is a steep change of over 700 feet in elevation between the ground level at the entrance to the underground parking structure and the plaza at the top of the hill. Located on the promontory edge of a ridge that runs roughly north and south along the San Diego freeway, the site proffers up a dramatic southerly view of the Los Angeles basin; of Bel Air, one of the most affluent residential communities in the city; and of the ocean. This

area forms a low-lipped bowl, open at the south and west, and borders the ocean. The light bouncing through an atmosphere that has both desert clarity and sparkling reflection from the ocean envelopes the region until midday, when the sun relentlessly beats down. The early morning light may have an airy, luminous opacity that progressively evaporates to produce crisp, strong shadows.

The peculiar and beautiful quality of light and wondrous perspective are used by Deal as supporting features throughout his images. They are present in the way in which the sides of buildings visually pop and separate from the low foliage of what lies around and adjacent to the site, in flattened views amidst the steel framework, in the glow of handrails and stairways and how it rakes deliciously across raw stone surfaces. The full beauty of the architecture emerges when the split travertine stone is applied. This skin, a layer of landscape brought upright, is the coda of *Topos*. The irregular, granular surface of the stone, similar in texture to the roughed-up soil, is used by Deal to bisect images vertically. These surfaces are used as *reveals*, both for the fossil remnants held captive in the stone and for the spaces that are delineated among the buildings.

<p align="center">+ + +</p>

"... ever behind the sunset, safe till the next Territory to the West be seen and recorded, measur'd and tied in, back into the Net-Work of Points already known, that slowly triangulates its Way into the Continent, changing all from subjunctive to declarative, reducing Possibilities to Simplicities."

— Thomas Pynchon, *Mason & Dixon*

In the fall of 1998, almost a year after opening to the public, one emerges from the underground parking structure into a canopied tram area lined by a promenade of trees at the base of the hill. Lines of planting are still visible. Small communities of cul-de-sac streets and stilted houses hug the hillside across the freeway. The Getty Center is a destination to visit—one does not stroll by and drop in—and it is separated from what is "down below" or the view across the freeway. It is detached from the twenty-four-hour life cycle that passes below. In the morn-

ing, no one will wander down the plaza in a bathrobe, nor are there likely to be stray dogs nosing around the tram platform greeting disembarking visitors.

The activities, programs, and collections that now constitute the Getty Trust were being developed even as Deal made his photographs. The institution is, after all, the activities and a history of activities, not the raw framework and space where the activities take place, which can only symbolize, or stand for, those activities. These photographs by Deal are the *tabula rasa,* the blank slate on which the Getty will write its future history. It is the site where culture is constructed. Any other information about the Getty is anecdotal. It would be circumstantial evidence, like the stories Deal can relate, such as the earliest site visits when he was bitten by a dog and confronted by a man with a painted blue face who emerged from the underbrush; flying into Los Angeles during the riots; or visiting the site after it had rained as hard and long as it does every hundred years.

There are many symbolic implications to this project. The construction is an inorganic complex matrix, a honeycombed organization of space, and is only fully defined by an addition of organic activity. This is the way a mechanized civilization builds culture, like the assembly of a gigantic computer before data are input. Even the selection of this site is symbolic, as nonconformity is an appreciated component in the act of creativity. The changes effected on the physical site are a prescient echo of what later will occur there. The act of dissipation or displacement is the basis for museum collections—taking the highest forms of artistic expression from one place and spiriting it off for display and appreciation in another. The transaction need not be viewed as loss or addition, but give and take—an endless tug of war in the inevitable march of entropy.

+ + +

The West is less a place than a process.
— Wallace Stegner, "Thoughts in a Dry Land,"
in *Where the Bluebird Sings to the Lemonade Springs*

The buildings of Los Angeles do not occupy landscape as much as they sit atop it, like a thin membrane of oil floating on water. This site may be the most documented building construc-

tion since photography was invented. Or, it may be the most documented museum construction since Edouard Baldus photographed the construction of the New Louvre (1855–57). The implications of these factors aside, the act of construction is unavoidably the record of human efforts that eclipse, add to, or introduce a new phase into nature. The photographs depict moments of a transition as the site is changed from one phase to another. They also mark the physical manifestation of where, and by inference how, those activities will take place. Whatever happens in these photographs—a past that can never be reenacted—happens in relation to the land, the only constant in Los Angeles. However, these photographs are not a parable or rehearsal, but the "real thing."

It is not too much of a stretch of the imagination to surmise that the land is what ultimately matters to Deal. His last views move back and place the buildings on their site, the edges of the flora appearing as a reminder of the ever-present natural world. The photographs in *Topos*—meaning site, position, occasion, and place—are of the Getty Center and about the land. The map does not so much describe a place as it constitutes a promise of what might be found there. *Utopia,* the title and subject of a book by Sir Thomas Moore (1516), was about a perfect social and political system on an imaginary island. Derived from the Greek οὐ τόπος, it means "no such place." So it is true with *Topos.* The Los Angeles that exists outside of Deal's first photograph is not the same Los Angeles that is outside his final image. During the thirteen years of the project, there were over a dozen major cultural institutions added or renovated in the city. (The *there* that was there is not the *there* that is there now.) These images happened at the site of the Getty. They can be about the place; any opportunities that might have been imagined now belong to a discussion of the Getty as a cultural institution. There is a Greek proverb "ὁ τρόπος καὶ όχι ο τόπος," which means it's not *where* you live, but *how* you live.

Mark Johnstone is administrator of public art of the Department of Cultural Affairs for the City of Los Angeles. He was curator of Joe Deal: Southern California Photographs, 1976–86.

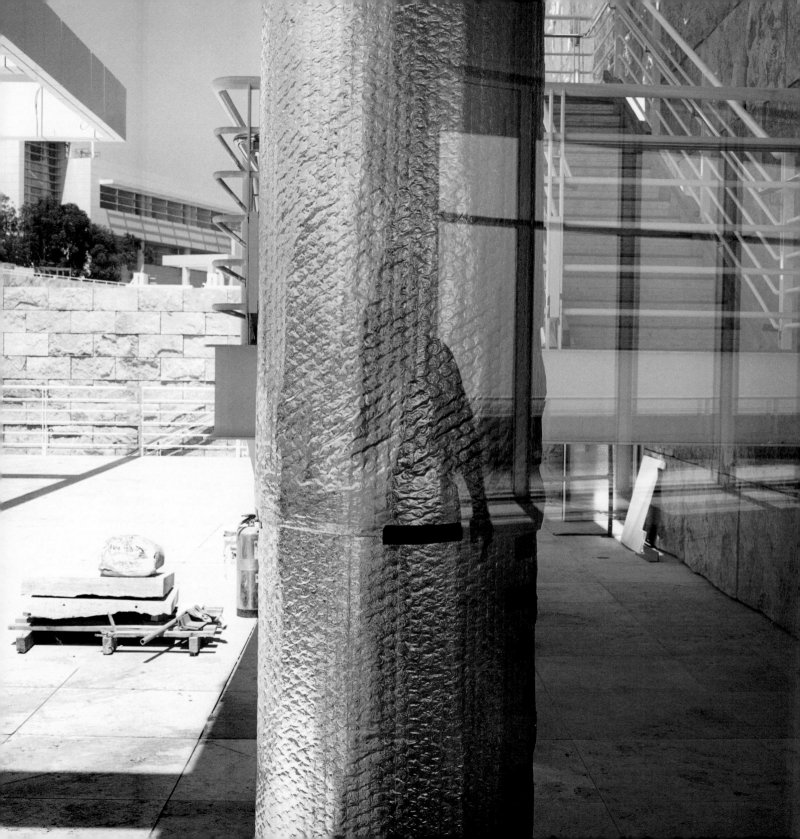

The Transformation of a Landscape

Joe Deal

I N 1983, KURT FORSTER, then director of the Getty Research Institute, approached me with the idea of photographing the site and construction of the Getty Center. Forster was familiar with other works of mine that dealt with the changing Southern California landscape. I was hesitant at first: I had never been tied to one location or one architect's work. Also, I'm not really an architectural photographer, and regardless of which architect was chosen—none had been selected at that point—I wasn't really interested in trying to interpret someone else's work. Finally, the length of time that would have to be committed to the project seemed long—at the time it was projected that the buildings wouldn't be completed until 1990 or 1991.

On the other hand, it was an intriguing proposal: Like the places I was photographing at the time at the eastern edge of the Southern California basin where housing developments were sprouting up, the Getty site was undeveloped. However, it was located in one of the most expensive and highly developed areas at the western edge of the city. Also, the idea of photographing a major piece of architecture under construction had some appeal.

About that time I read an article by Vincent Scully, in which he predicted that the most important American architecture of the post–World War II era would be that of suburbia and art museums—suburban architecture, which I had already photographed extensively, for its sudden and widespread appearance on the American landscape, and art museums because they gave the architect the opportunity and resources to do major work, as with cathedrals in an earlier era.

Forster arranged for me to get a tour of the site. The opportunity to photograph the process of change seemed irresistible. The focus of my earlier work was on the transformation of the landscape by developers who subdivide the landscape into real estate properties and by homeowners who then invest the property with values and personal history. I was interested in the Getty Center site because it was a place that had somehow escaped development. It was an

island or peninsula of scarred mountainside surrounded by a carefully constructed landscape—of swimming pools, flowering trees, and tile rooftops—that was about to become a cultural symbol unlike anything else in the neighborhood, or even the country. Even before it was designed, the Getty Center was being compared to the Acropolis. So, it was clear that, in its transformation, this place would take on a very strong identity that would set it apart from its surroundings.

Almost all of my work has been concerned with the changing landscape. However, my interest in the Getty project was less about the landscape in its untouched condition or in the finished architecture than about the boundaries or the lines of tension between the environment and the construction of culture. These tensions were most evident—as they are in many places in Southern California—during the process of transformation. An earlier portfolio of photographs I had made, *The Fault Zone,* explored the tensions beneath the surface of the landscape and on which all of this culture rests. I was interested to learn that these lines of tension existed, literally, on the site of the Getty Center from a geologist who was working there and had exposed the fault for inspection (page 43). There were other tensions that interested me, for example between the randomness of the native vegetation and the order of the buildings; or between the site, the buildings, and their surroundings.

Working on a project that was deeply rooted in architecture intrigued me. I have always been aware of the historic connection between photography and architecture, and have been interested in looking at how other photographers have handled this subject. I knew of Carleton Watkins, A.J. Russell's photographs of the construction of the Union Pacific Railroad tracing the lines connecting east and west; Lewis Hine's photographs of the building of the Empire State Building; and Peter Stackpole's photographs of the building of the Golden Gate Bridge. There's a wonderful book by A.J. Waldie called *Holy Land* that includes William A. Garnett's photographs of the construction of Lakewood, California—one of the first suburban developments in the country. Then there are my friends and contemporaries: Lewis Baltz, who photographed the construction of Park City, Utah, and Catherine Wagner, who photographed construction of the Moscone Center in San Francisco. So, I saw my work on the Getty Center as belonging to a long line of photographs that document the making of the built culture of the West.

The finished portfolio, *Topos,* is a series of 162 photographs taken at regular intervals from 1984 to 1997, except for a gap from April 1989 to April 1992. In 1989 I moved to St. Louis

to take up my current position as dean of the School of Art at Washington University. With my move came the decision to stop my work for the Getty. I just assumed that the distance and the demands of my new job would make it too difficult to continue. Also, I felt that I had come to the end of the portion of the project that dealt with the site before construction, so it was easy to conclude the project at that point with the completion of the first portfolio.

Then, on a return trip to Los Angeles in 1992 for the opening of an exhibition of my Southern California photographs at the Los Angeles Municipal Art Gallery, I was invited back to see the changes to the site that had taken place since I had left. The changes were amazing. The chaparral had been cleared and the site was just an eery blank slate. That got me hooked again—it was a totally new project.

I changed the format of the photographs when I returned to the project in 1992. Prior to construction, I used a rectangular format, which was appropriate to the subject; the horizon lends itself to the rectilinear format. But anticipating the change in landscape, the geometry of the square format seemed more suitable. The square format is a passive frame, more flexible in framing what would become of the landscape as the buildings emerged.

In essence, then, the portfolio consists of two series: one of images taken before construction and the other of photographs taken during construction. Prior to construction, most of the site, in contrast to its surroundings, had a kind of uniformity of surface appearance: a mix of shades of brown and green and a light-colored soil where the ground cover had been disturbed. This is a landscape of subtle seasonal changes, however. I became attuned to the minor changes—not so much of form or color, but of line in the chaparral. It is this aspect of the site—its dense, random, crosshatched lines of dry brush and twigs—that I returned to again and again.

I was also interested in the more developed surrounding areas. Views of the hillsides east and west of the site, or of the more distant buildings of the city looking south, became the backdrops that were framed, or screened, by branches and the natural conditions of the site in the foreground. This play of foreground to background became a theme, or strategy, used throughout the project—the surrounding hillsides became a constant while the site itself underwent a total makeover.

One thing that had enticed me to return to the site in 1992 was the excavation work for the seven-story underground parking garage that was then underway. I really came back to see what a hole in the ground that size looked like. The photographs I ended up making of the

parking structure were taken at the bottom of the pit, and they're still, for me, emblematic of the process that was just beginning to occur on the top of the site as it was reduced to its most basic elements: earth, concrete, beams, light, and shadow (page 83). In the end, then, it was really the landscape—and the quality of light—that connected the process's beginning, middle, and end. The finished landscape is highly cultivated and ordered, a very different place than the chaparral-covered hillsides that had previously existed.

Originally, I chose *topos,* a Greek word meaning "place," for the title of the first portfolio of photographs of the site before construction. After completing the second portfolio, I looked for a new name that would indicate not only location but the entire process. *Topos* is the root for a number of other words, such as "utopia" and "topic," so for a while I searched for a word in English that incorporated it. However, in addition to "place," *topos* also means "site," "position," and "occasion," so it seemed like the right word for the finished portfolio.

Topos does not include photographs of the buildings after they were completed; I didn't make any. The buildings stand on their own without any need for interpretation. It was always my intention to interpret not Richard Meier's work, but the construction of culture in a unique site.

Joe Deal's photographs have been widely exhibited and appear in major museum collections, including The Museum of Modern Art, New York; the National Museum of American Art, Washington, D.C.; and the Museum of Contemporary Art, Los Angeles. A selection of his photographs was published in Joe Deal: Southern California Photographs, 1976–86 *(New Mexico: The University of New Mexico Press, in association with the Los Angeles Municipal Art Gallery, 1992).*

TOPOS

Passage

Site

Position

Occasion

Place

Passage

+ + +

THE PHOTOGRAPHS IN TOPOS are both an artistic interpretation and an objective record of the Getty Center site, its surroundings, and the emergence of the buildings and gardens. Each photograph can be read individually, but viewed together the images make a unique narrative of the changing landscape and evolving buildings. This narrative is epitomized in *Passage,* a series of photographs grouped on pages 27–31, in which the transformation of the site can be seen: the site in 1984, grading, foundation, steelwork, framing, walls, installation of the stone exterior, interiors, and, finally, a piece of sculpture waiting to be unpacked in its new gallery. The photographs that follow the *Passage* series address formal or conceptual aspects and are grouped thematically, according to the definitions of *Topos* (site, position, occasion, and place).

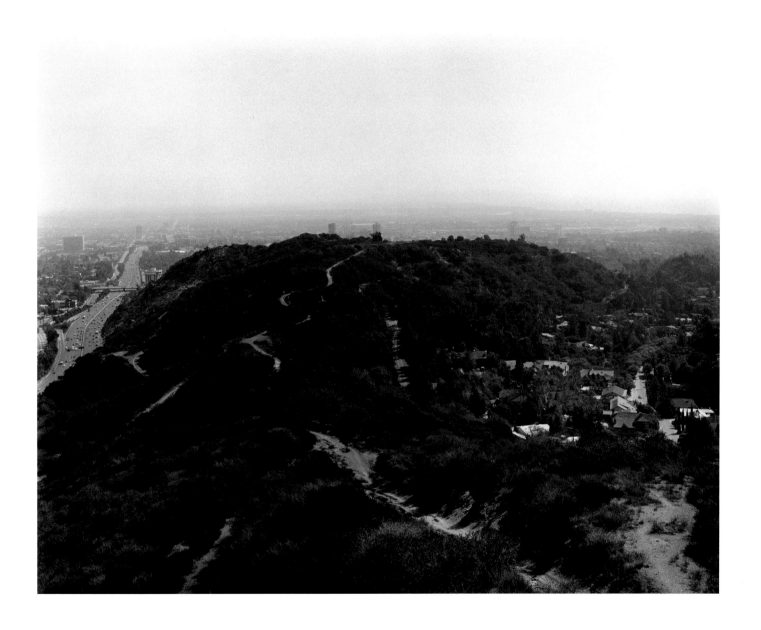

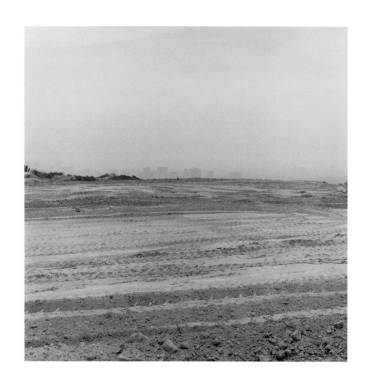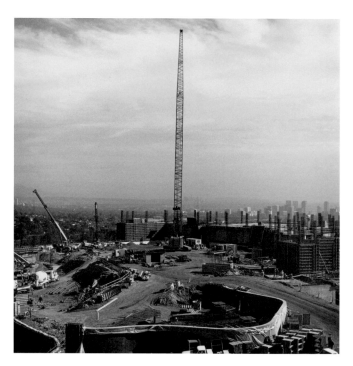

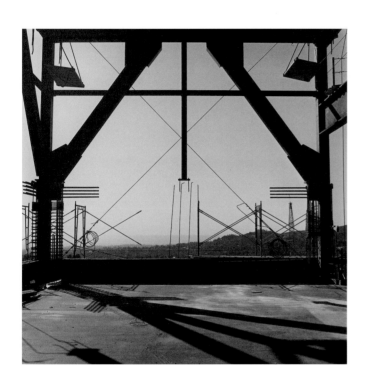

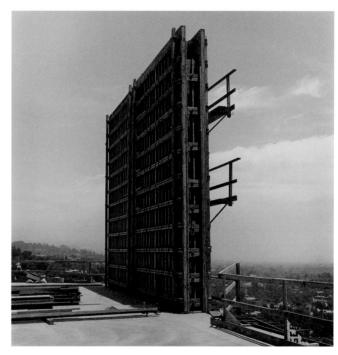

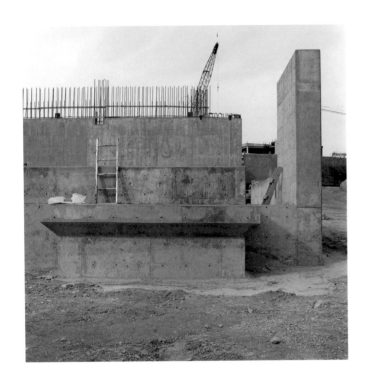

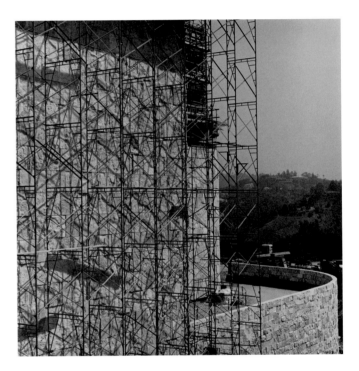

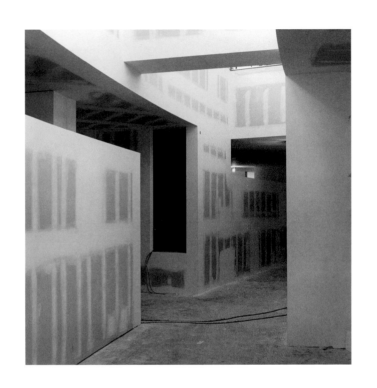 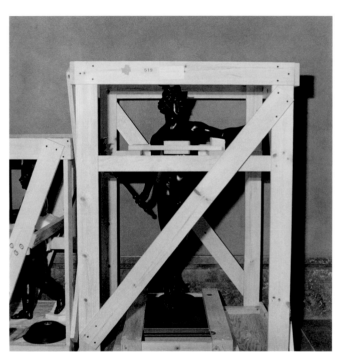

Site

+ + +

THESE EARLIEST IMAGES OF the site reveal a variety not so much of form or color but of line in the chaparral, which creates forms of amazing complexity and delicacy. Each line—the rounded surface of a branch or a leaf of grass—has both a dark or shadowed side and a bright sunlit side, giving the drypoint quality of the image an added intensity. These photographs capture this aspect of the site—its dense, random, crosshatched line of dry brush and twigs—and show how it has given way to the ordered geometry, not only of the buildings, but also of the replanting along the hillsides.

As the site becomes a place of construction, marks of intervention are evident: the tools of the surveyors, the trenches of the geologists, the patterns of the graders. The found objects and patterns—ladders, boulders, swirls—of these early photographs become leitmotifs that recur in later images. By placing in the foreground both the found boulder and the stone being hoisted into a courtyard, the presence of the site throughout its transformation is emphasized.

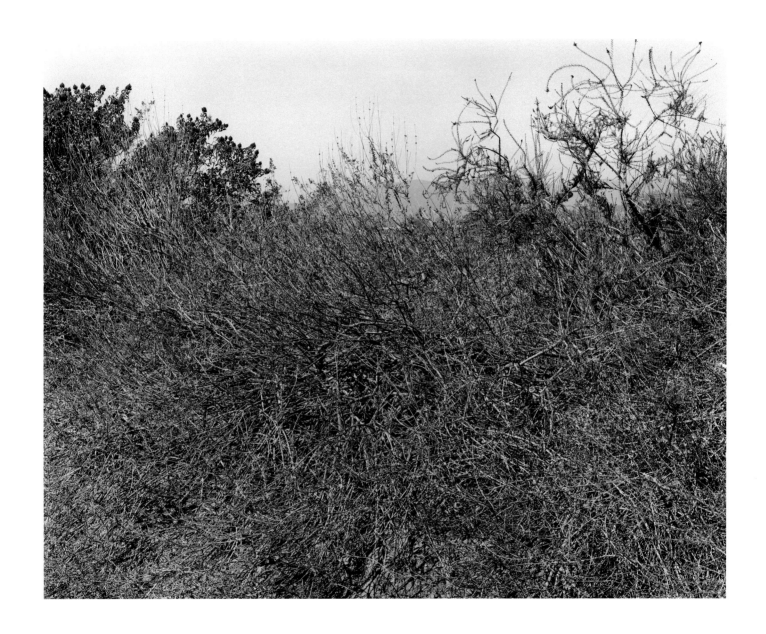

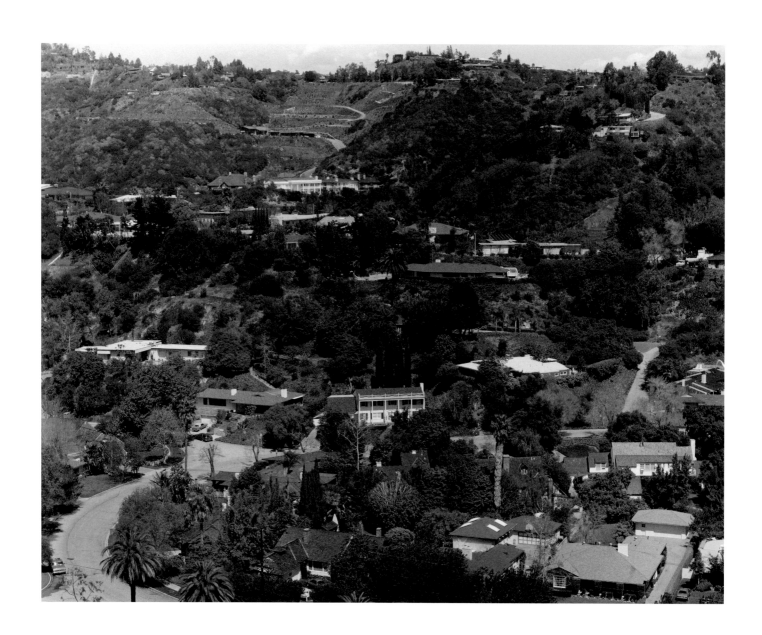

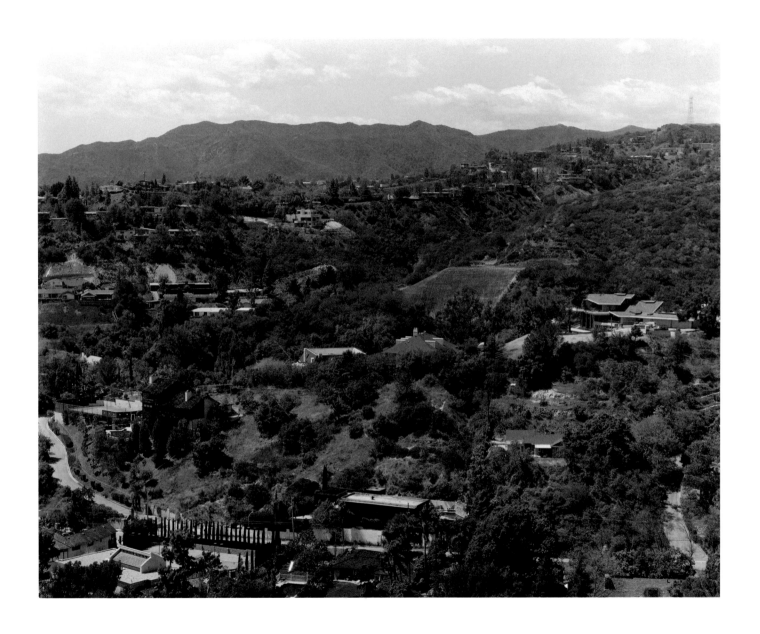

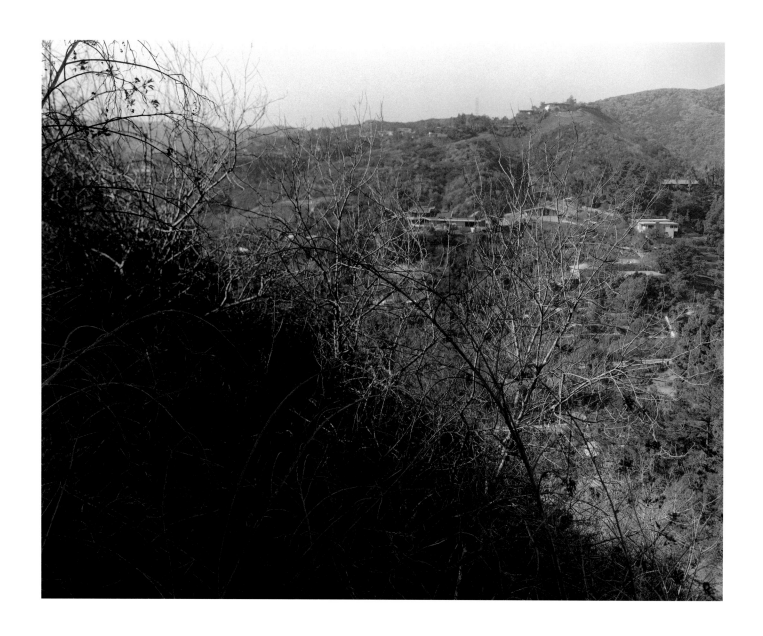

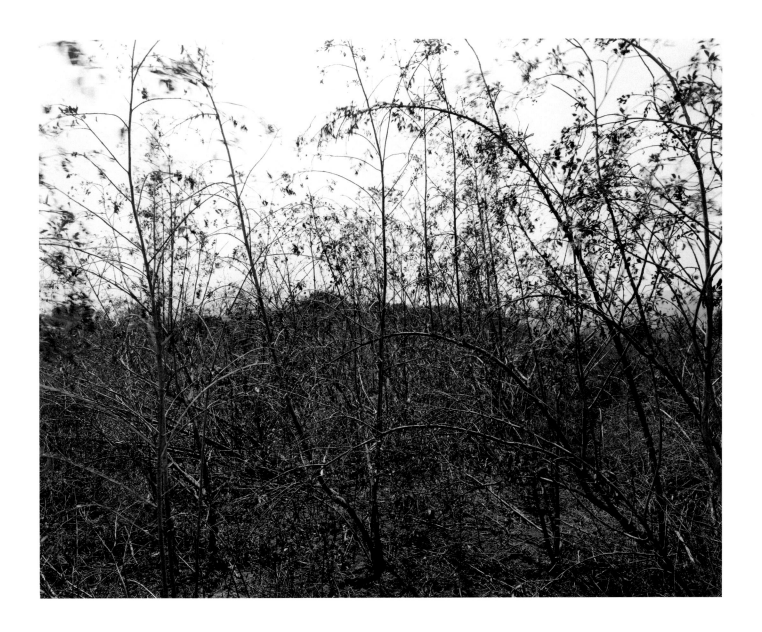

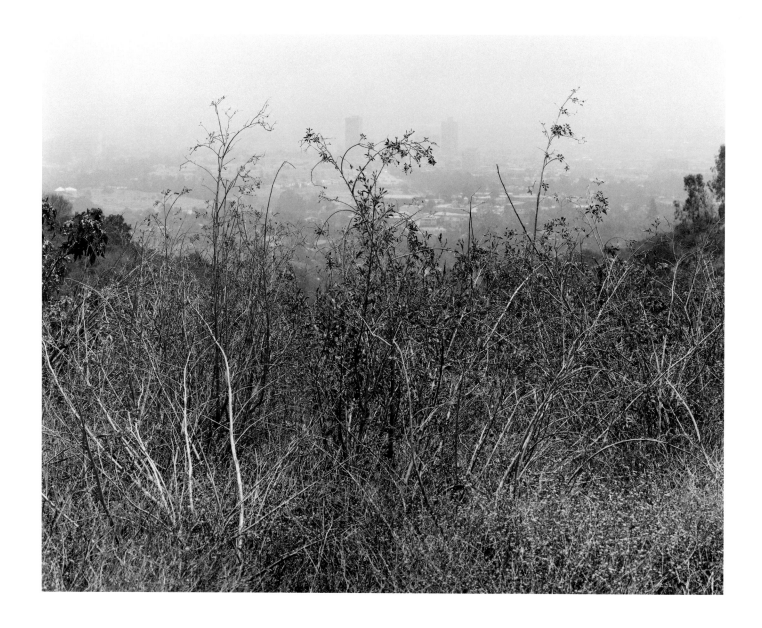

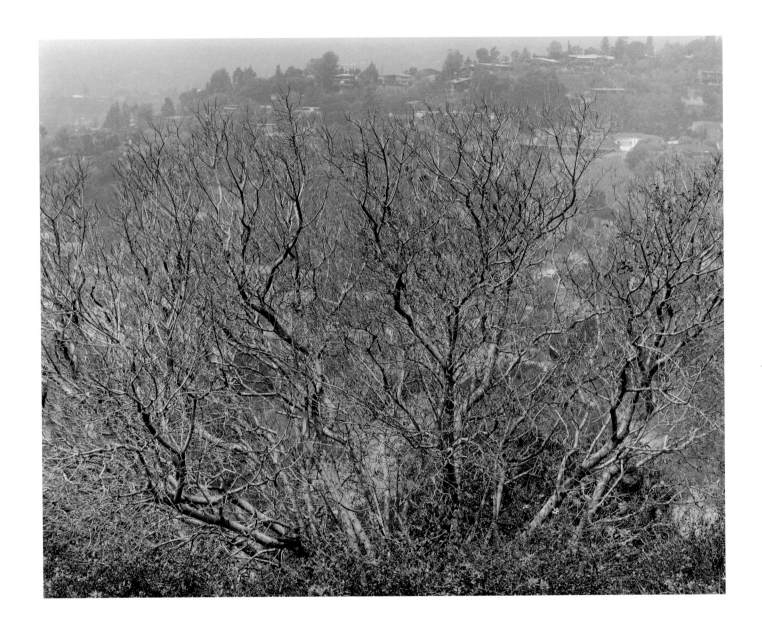

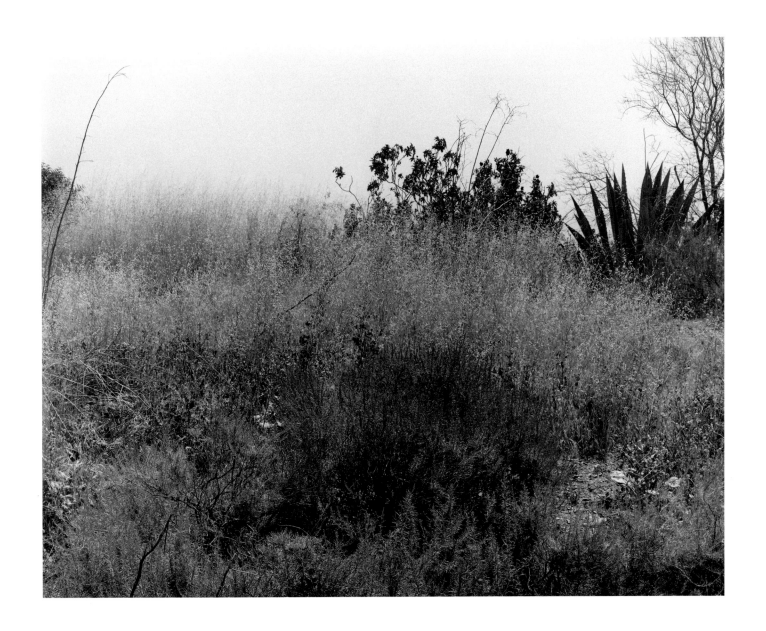

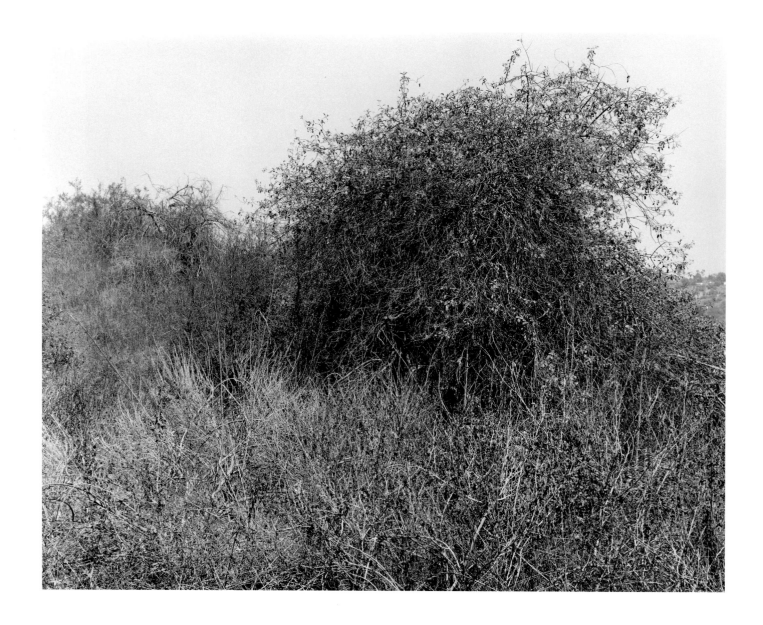

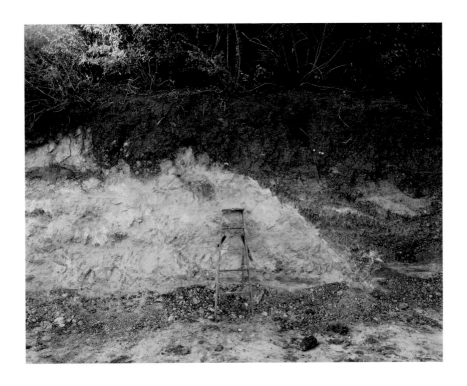

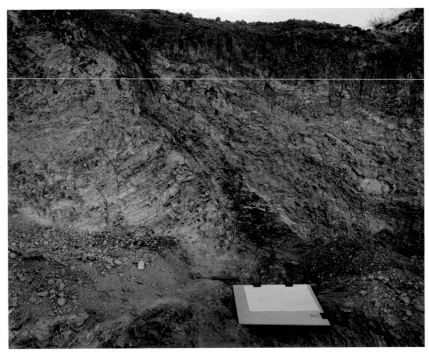

44

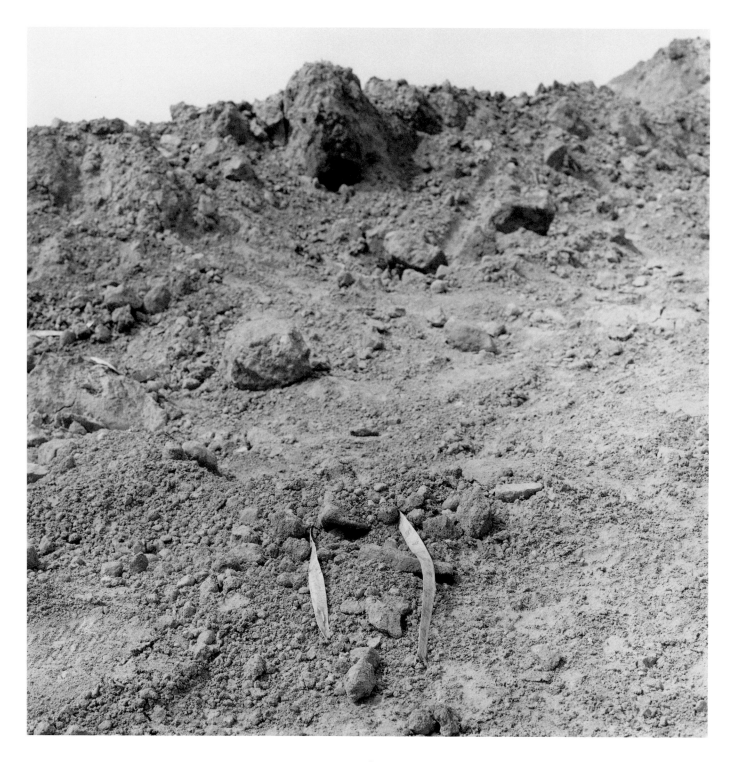

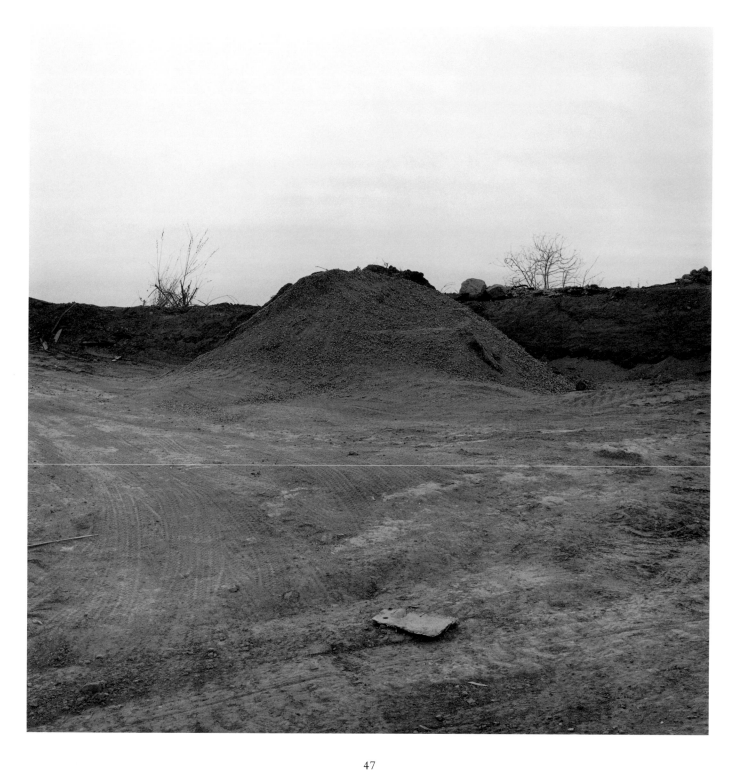

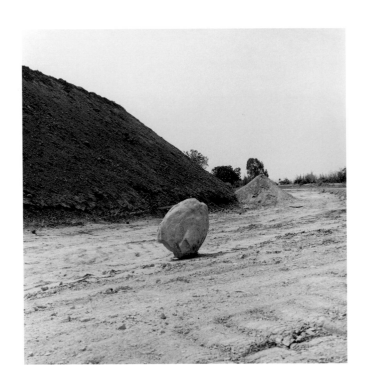 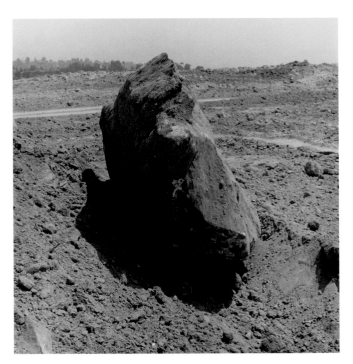

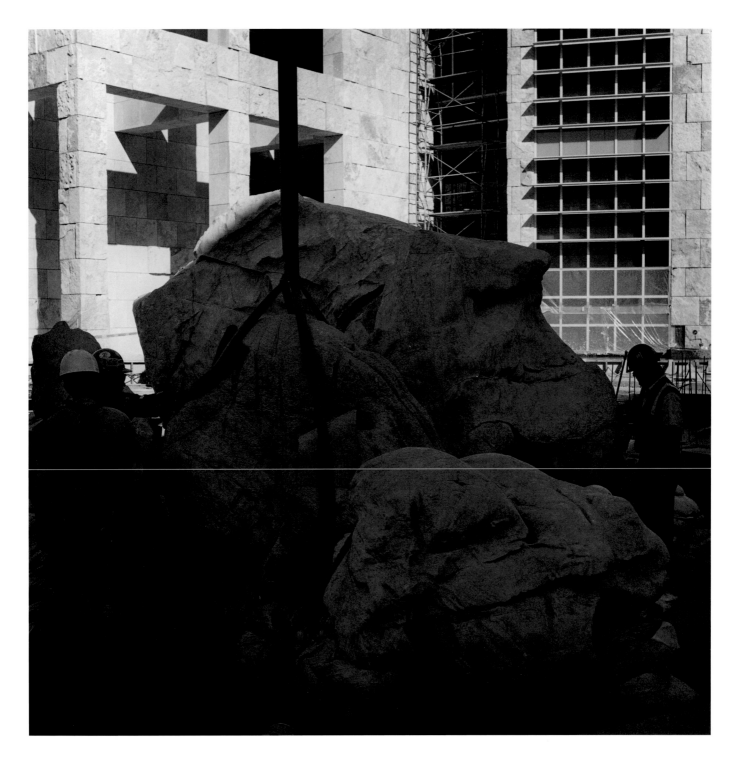

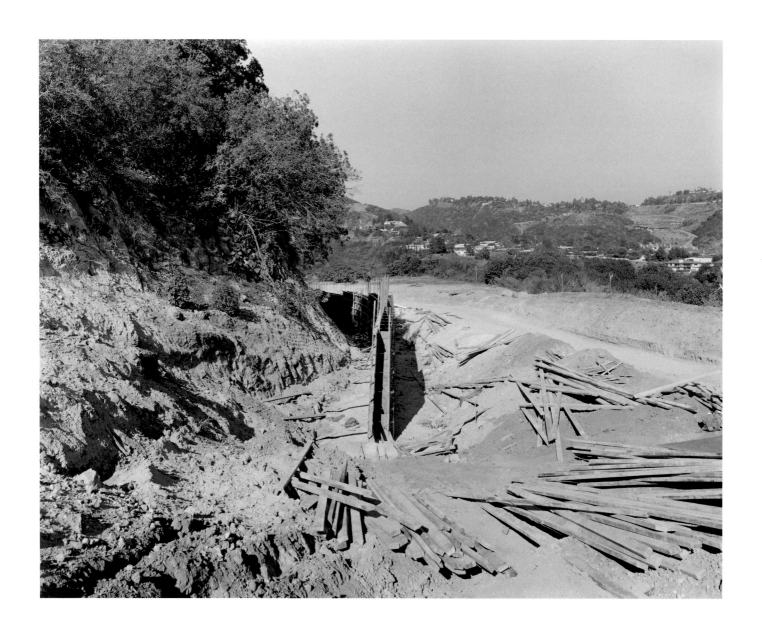

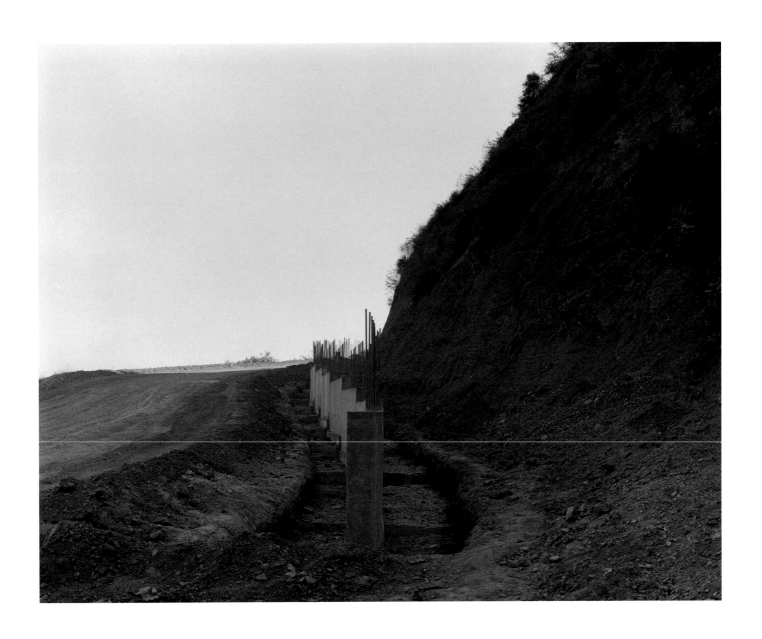

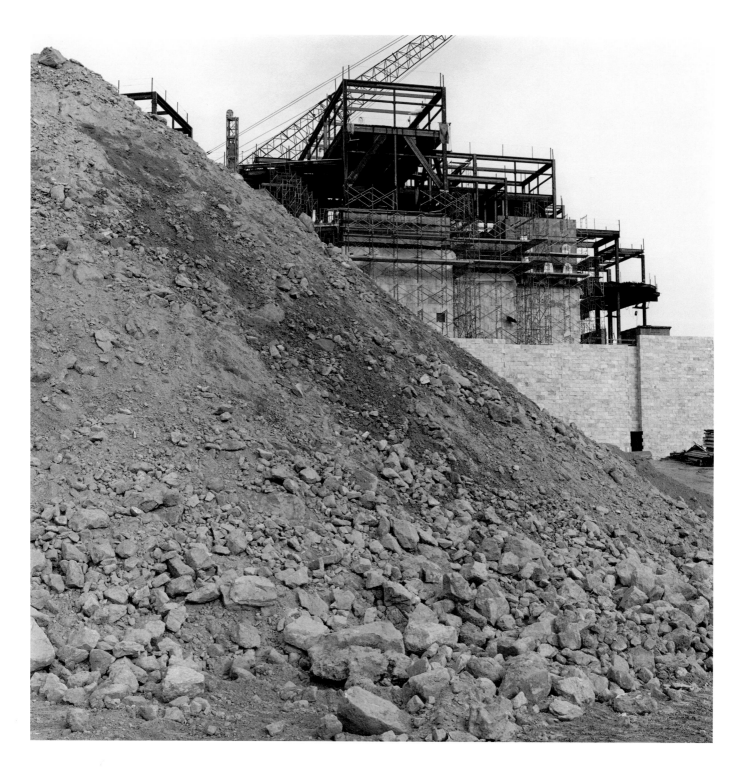

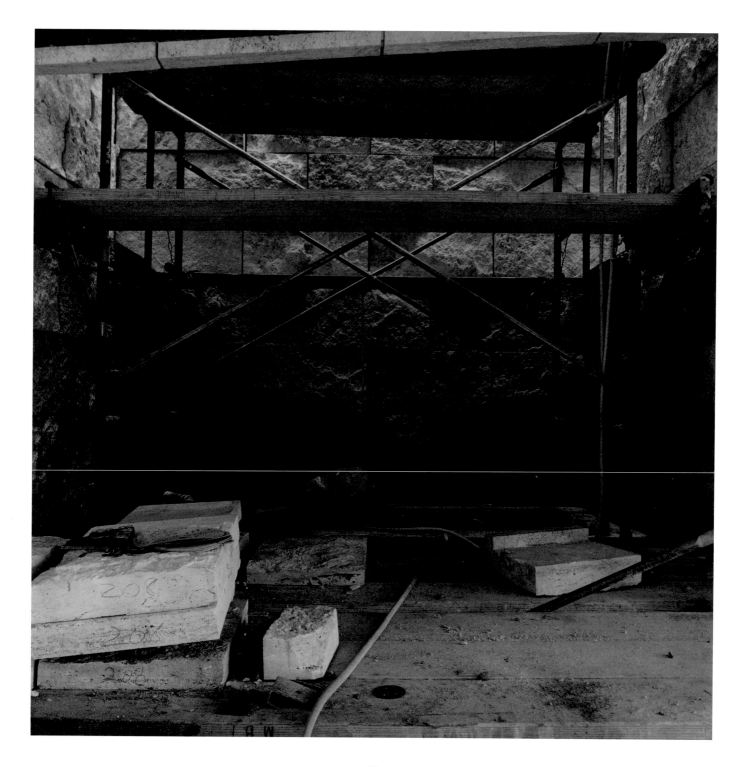

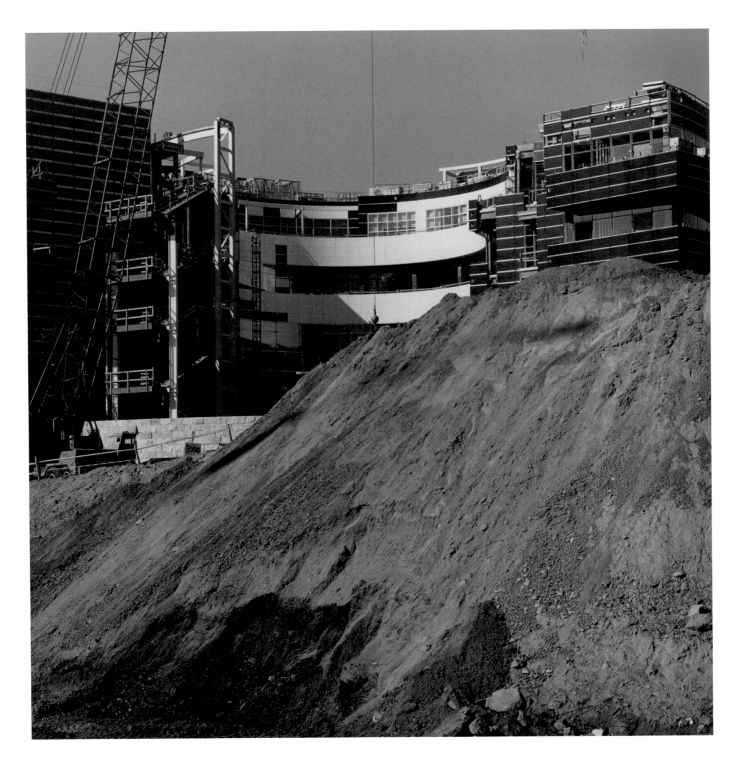

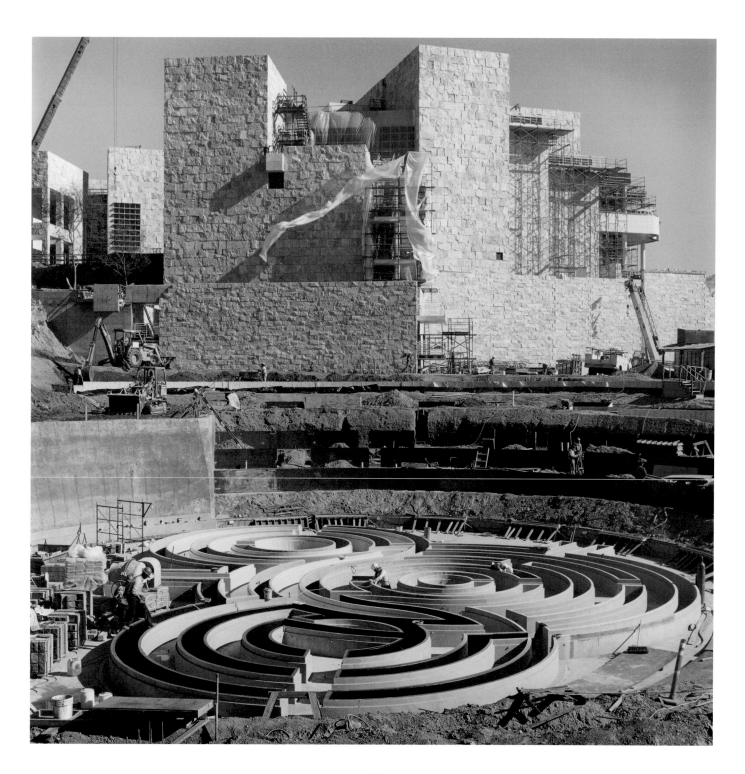

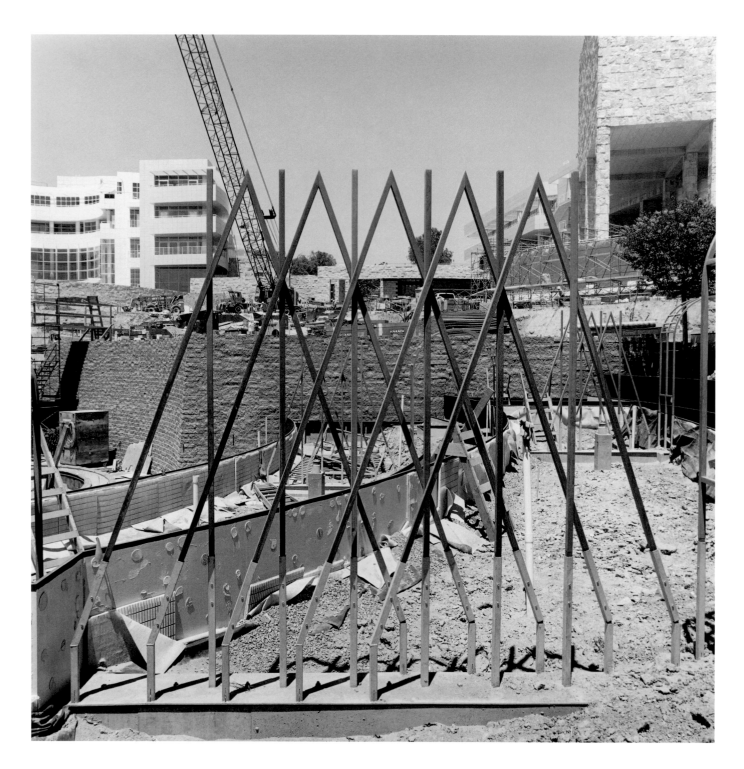

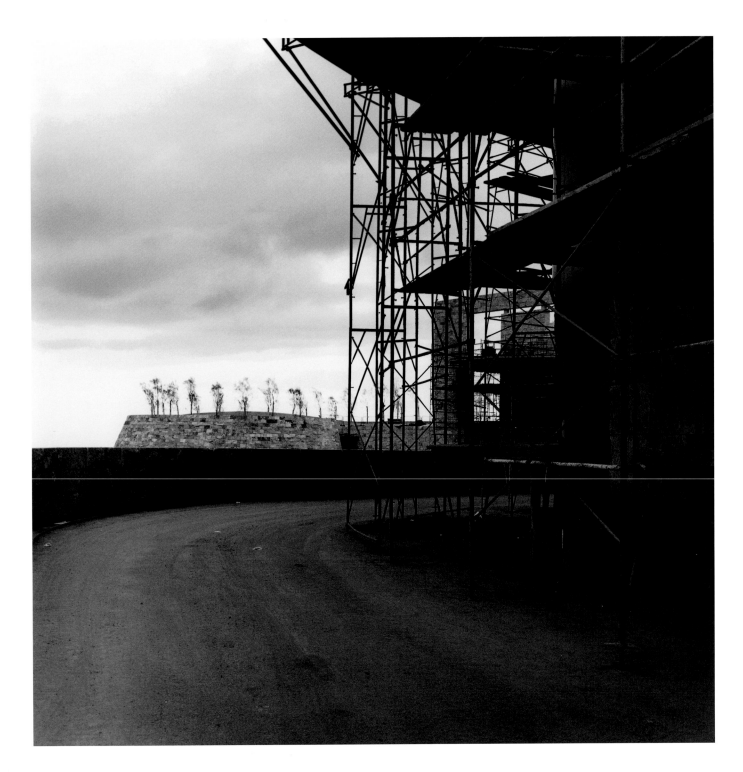

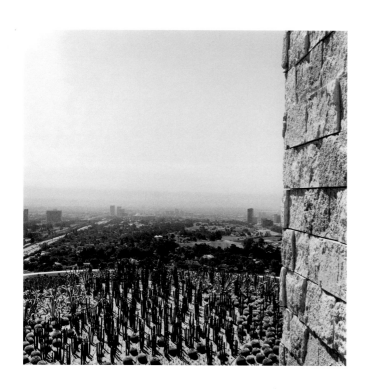

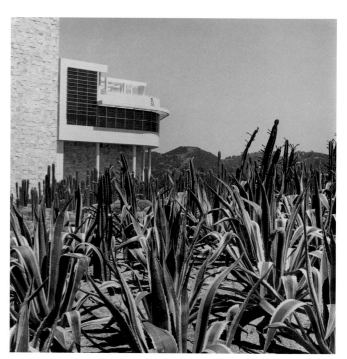

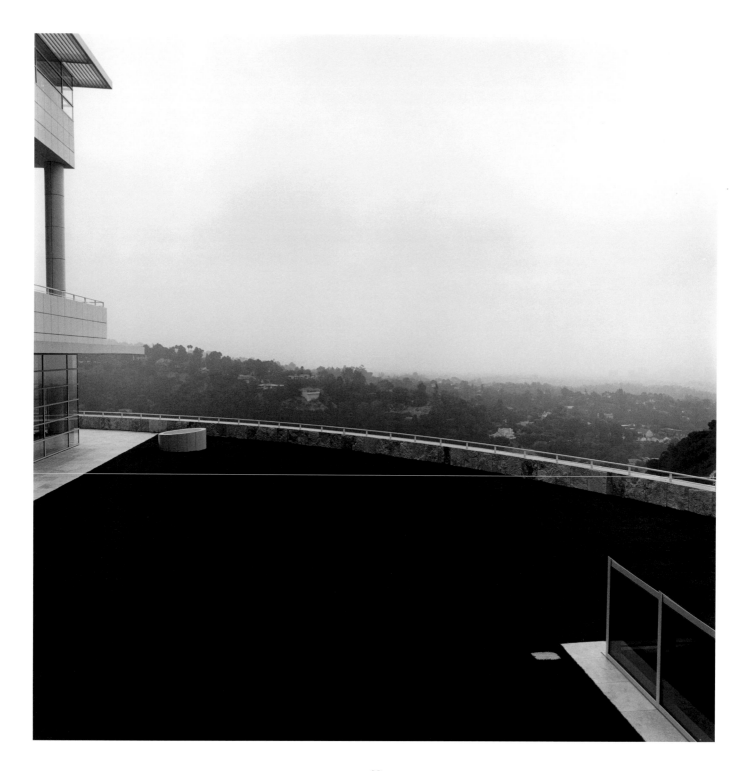

Position

+ + +

In these photographs, the interplay of foreground and background reflects the lines of tension between the surrounding area and the site under transformation.

The first three series of images (pages 61–73) are views that were taken repeatedly from different vantage points over the course of the thirteen years during which the site was photographed. The background view of the surrounding hillside remains constant, while the foreground views of the buildings change. In the early years of the project, the vantage points were selected before the decision was made about where the buildings would be placed. As the structures emerged, these same vantage points were revisited to create views that were now framed by the buildings.

In the last series (pages 74–81), the chaparral and then the construction process are utilized to create a screen or veil through which both the hillsides and the horizon are viewed. Before construction, the dense chaparral branches and brush create a scrim material through which one observes the surroundings. During construction, drapes of material—used to protect open areas when fire retardant is sprayed on the steel frames—create images that suggest a theatrical stage whose curtains have parted, revealing the hillsides as a backdrop.

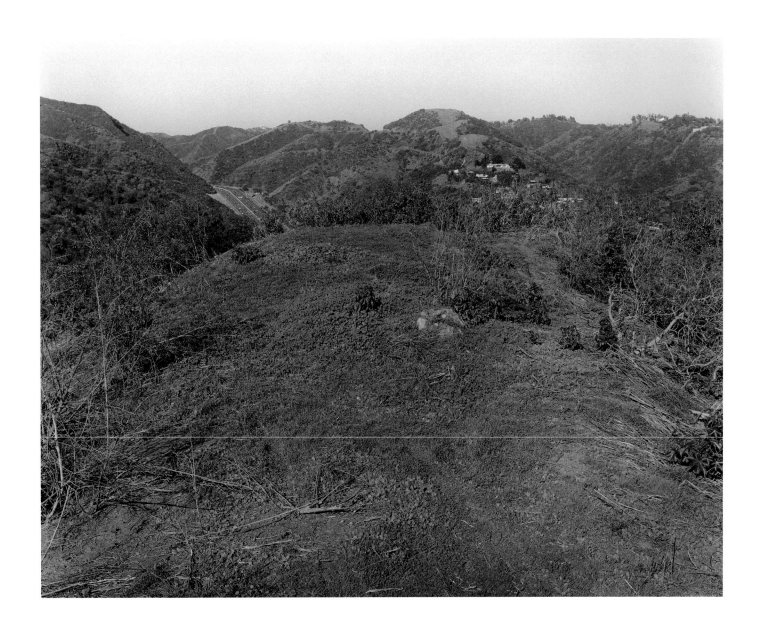

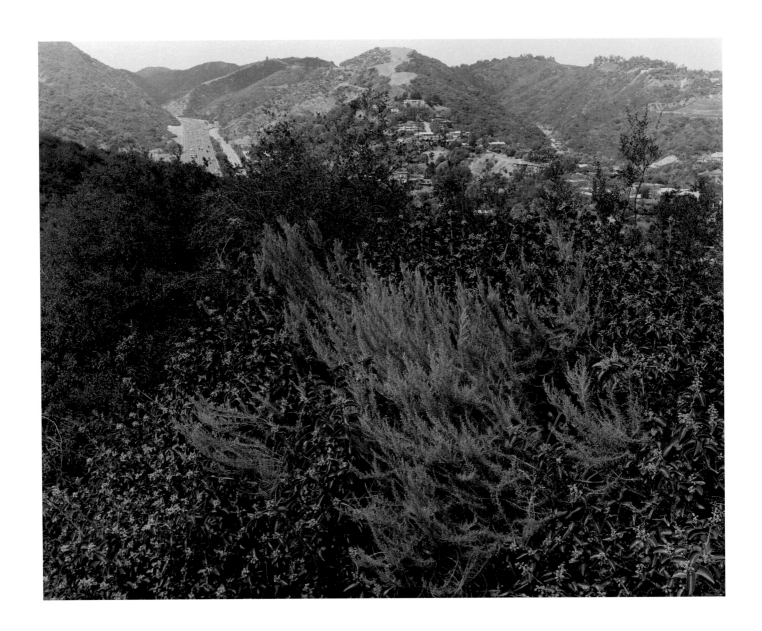

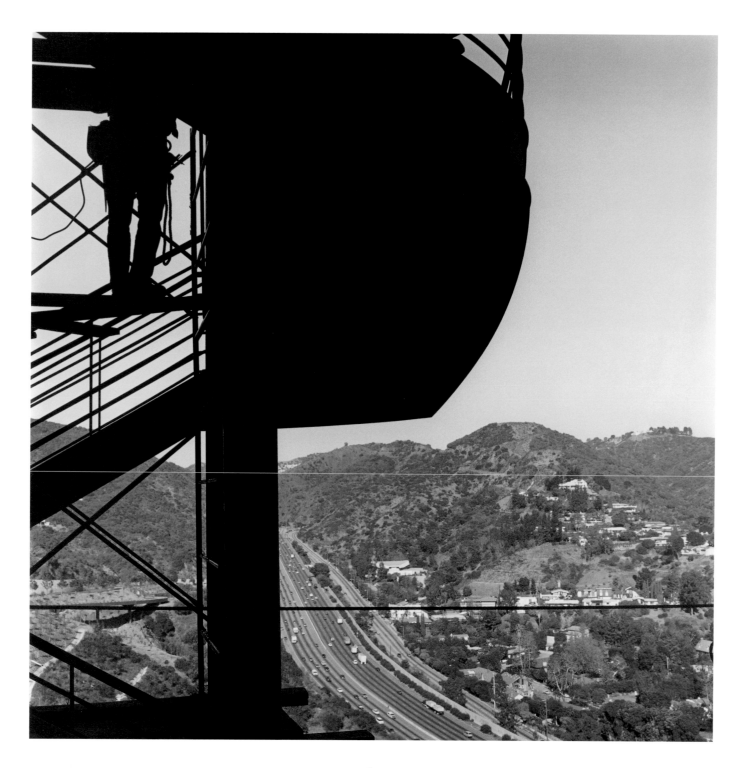

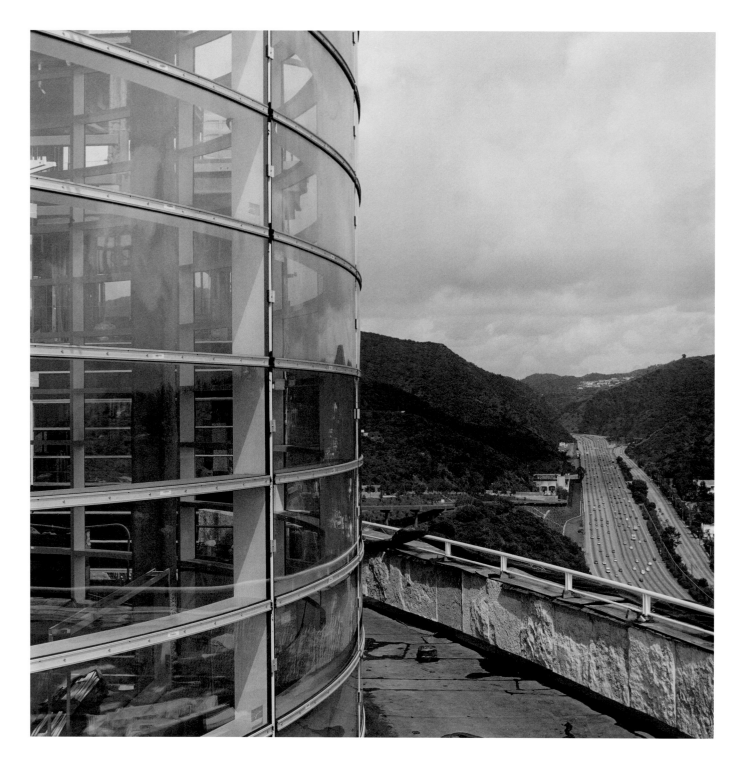

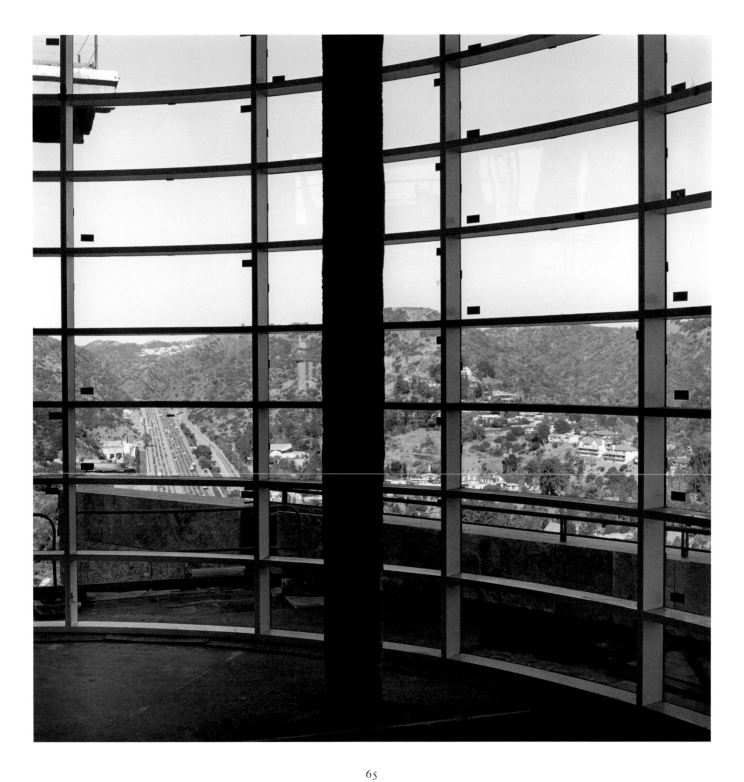

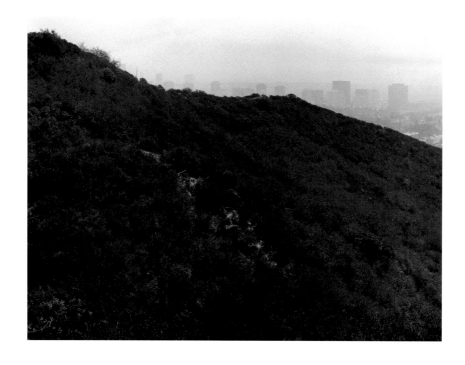

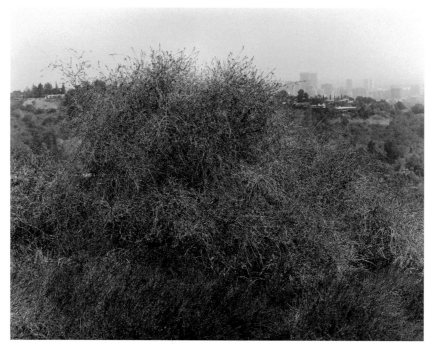

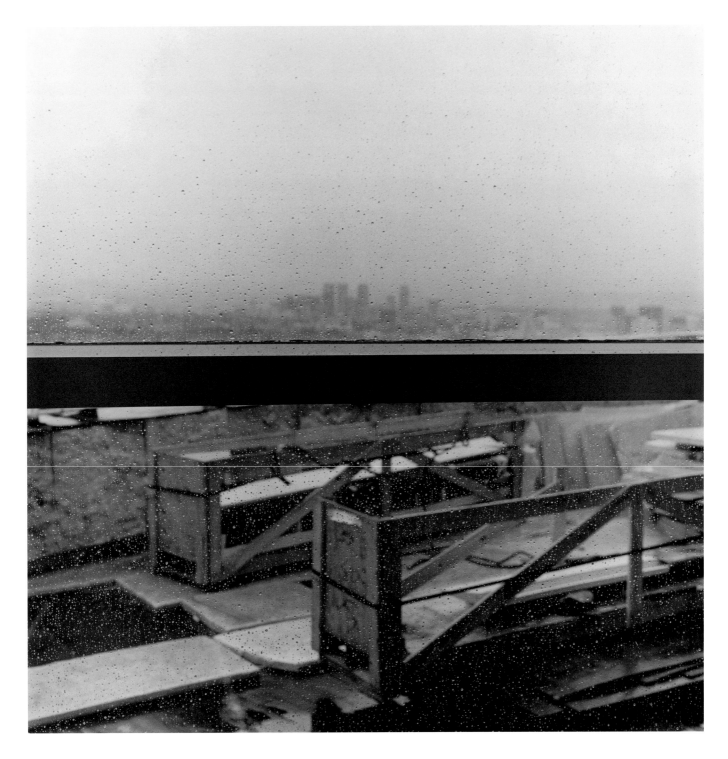

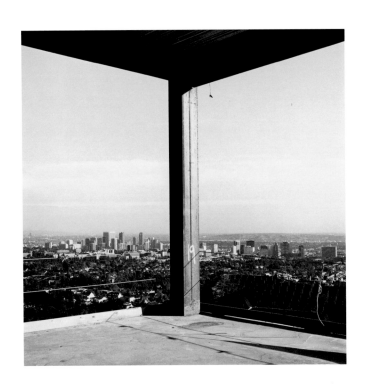

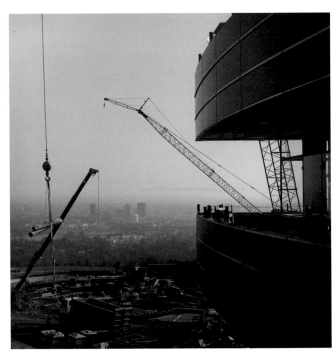

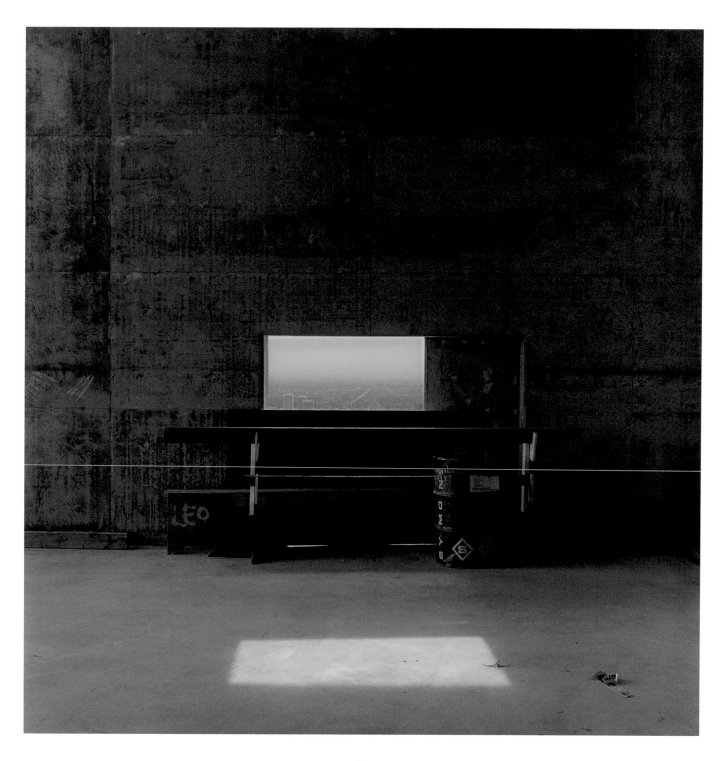

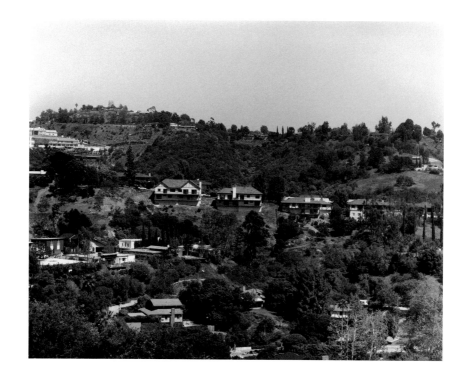

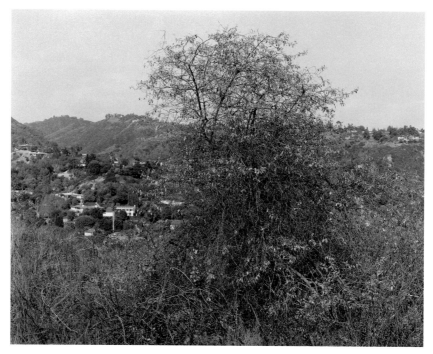

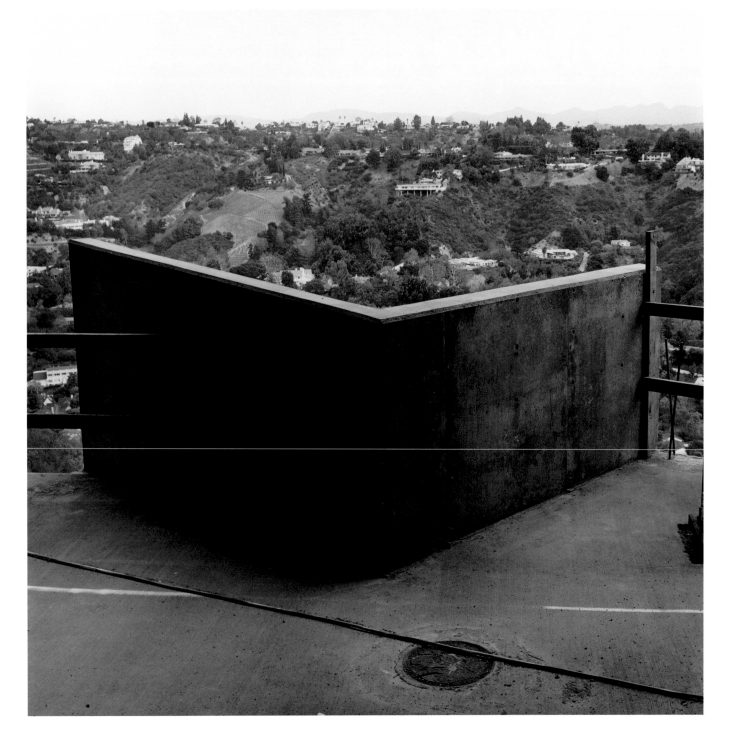

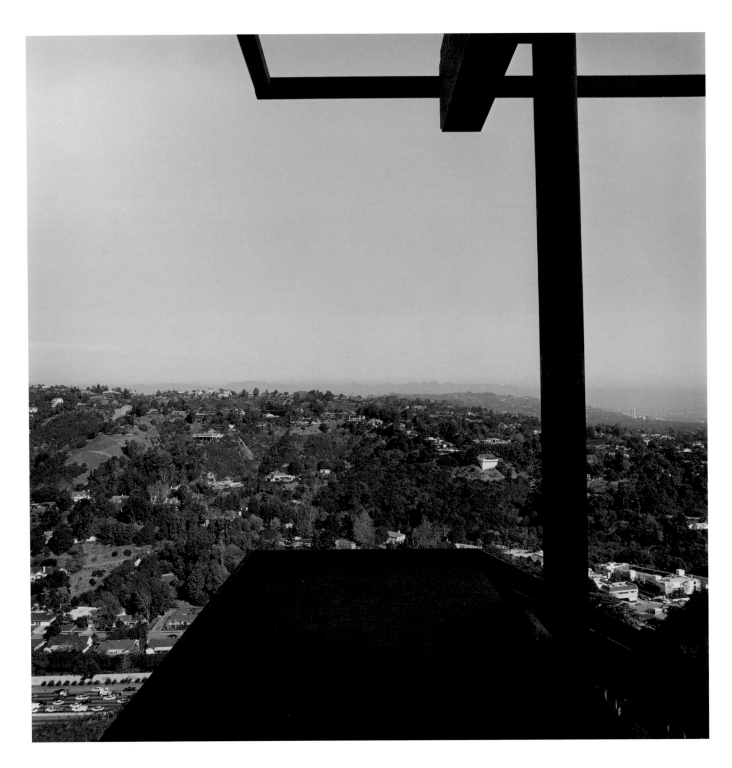

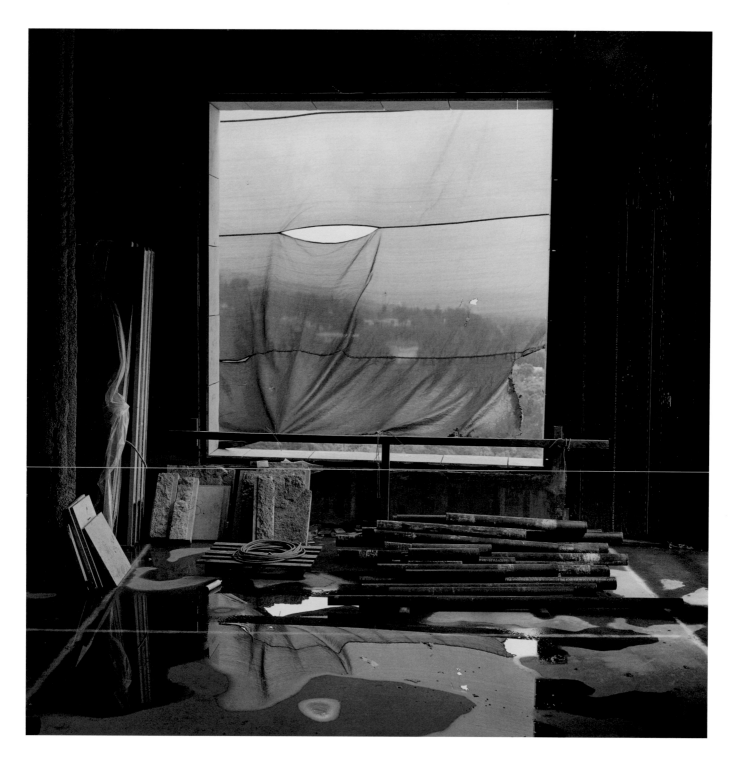

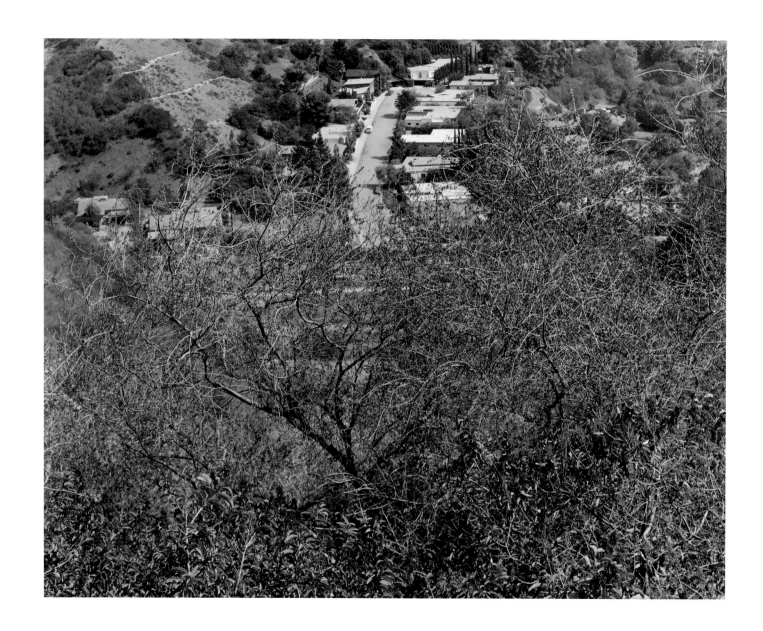

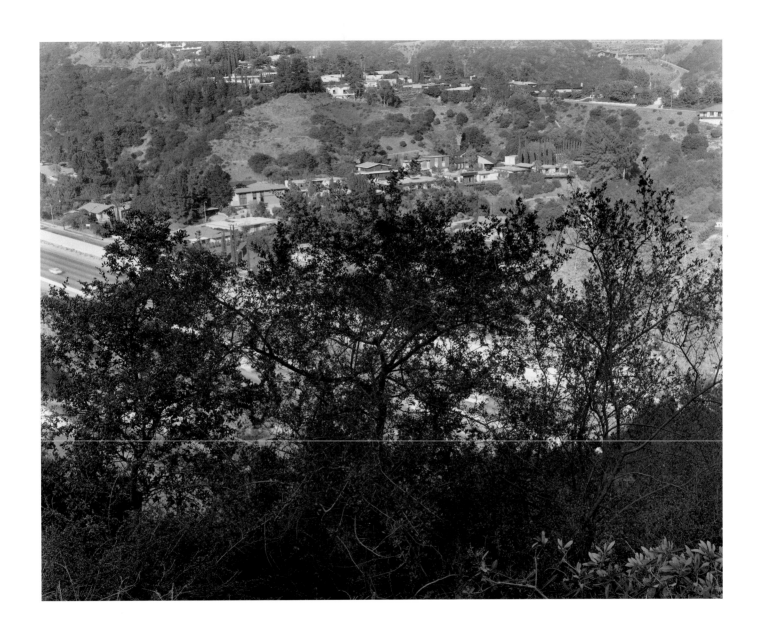

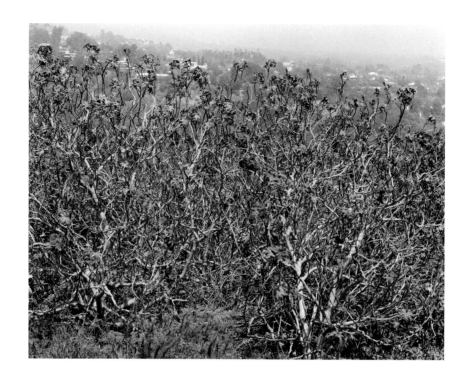

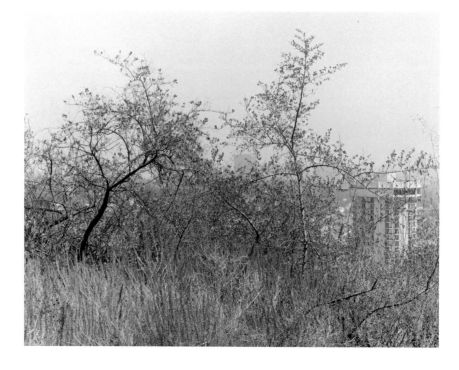

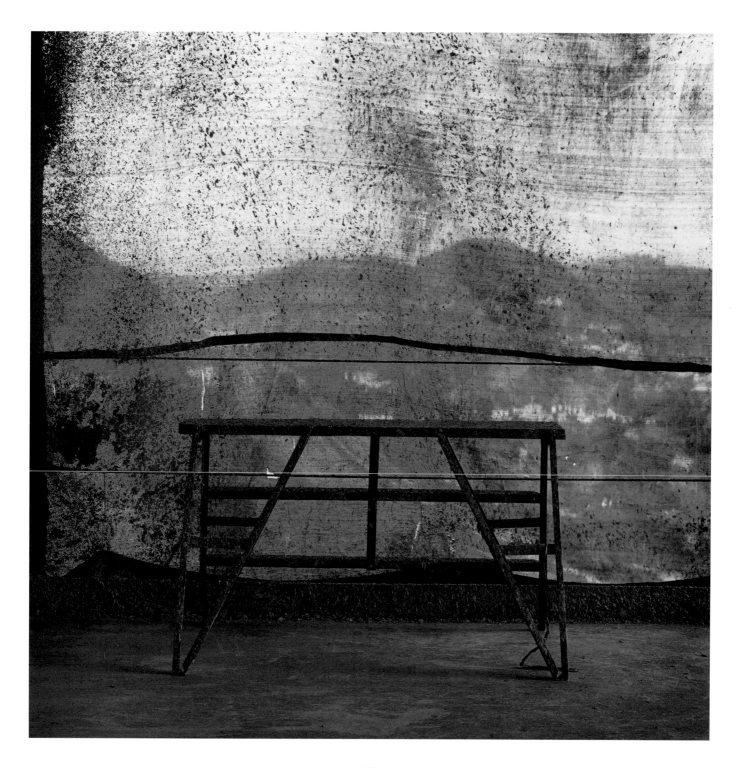

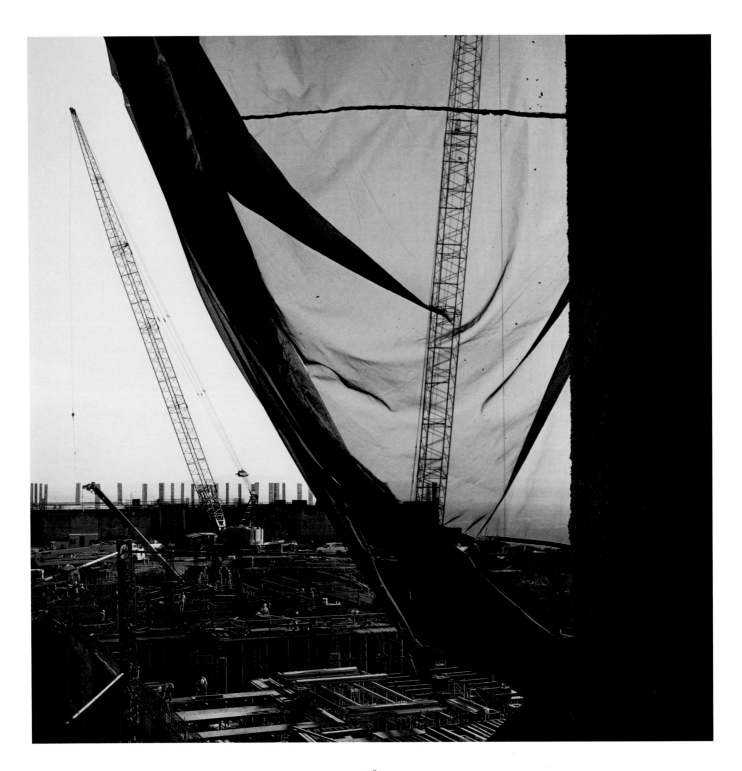

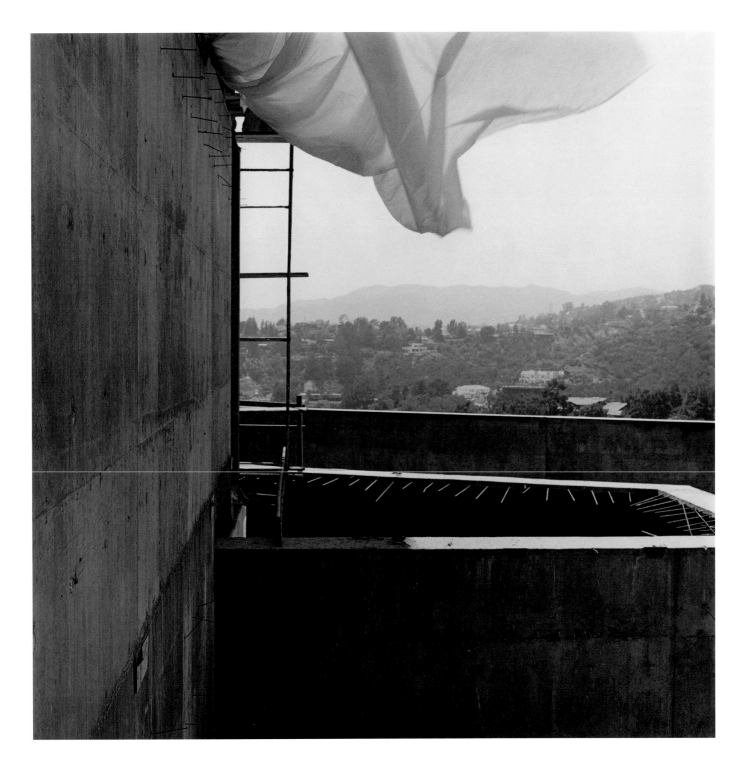

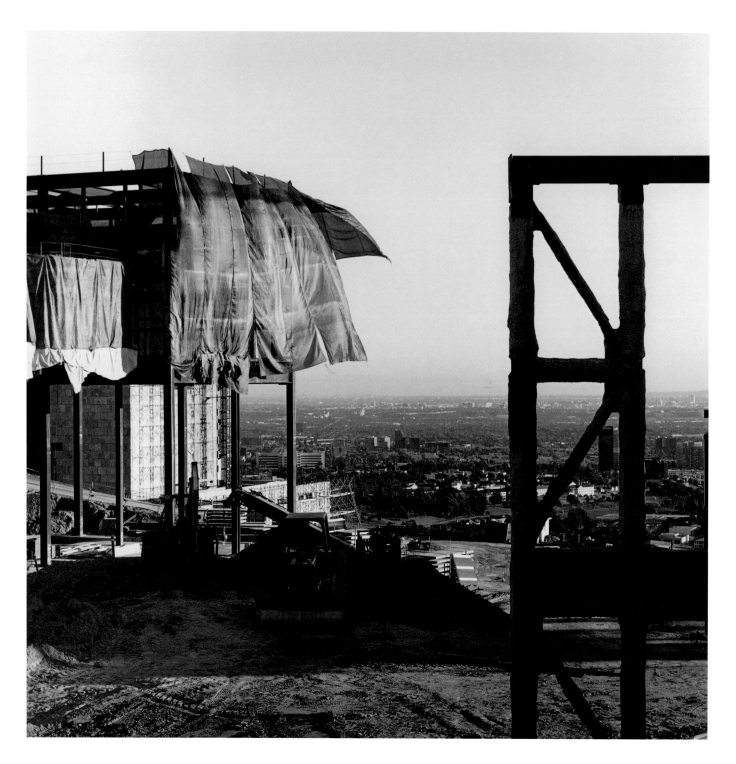

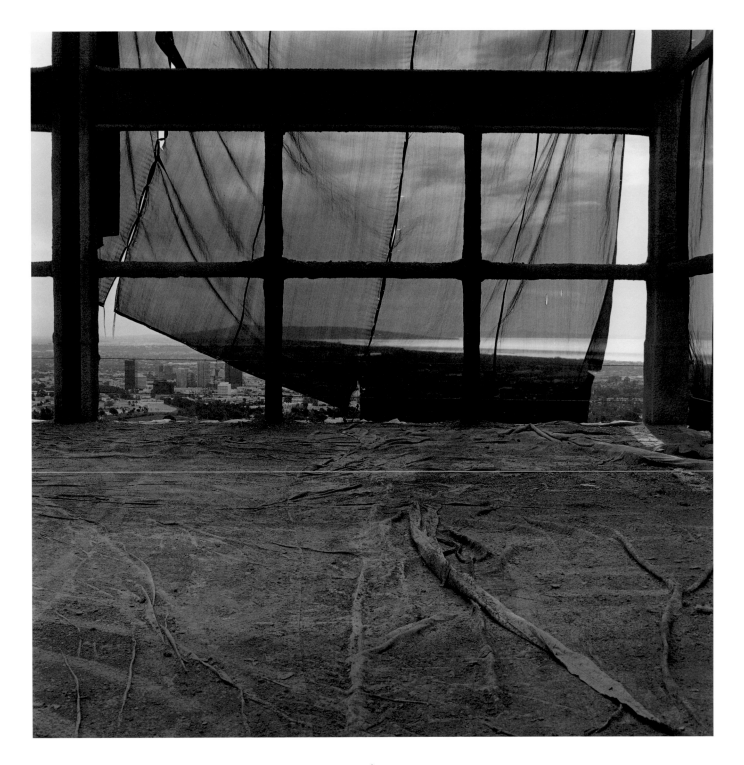

Occasion

+ + +

THE CONSTRUCTION PHOTOGRAPHS CREATED from 1992 to 1997 reveal the buildings' forms in a way in which, once completed, they could not be seen. These photographs are grouped to feature certain occasions in the building process: the buildings' foundations imprinted on the earth; the steelwork framing the buildings and their relationship to the surroundings; the concrete walls giving weight to the forms; and the appearance of such elements as windows and stairs that hint at eventual human use. The photographs that were made when the buildings were enclosed and interior spaces were created capture the way in which the light entered the buildings and reflected off the surfaces free of restraint or artificial light.

These images repeat certain leitmotifs that were present in the earlier photographs, such as the abandoned ladder. This deliberate connection can be seen between the photograph of the ladder leaning into an earth wall beneath the building (page 15) and its companion photograph made earlier of the geologist's ladder positioned against the earth in a test trench (page 43, *top*).

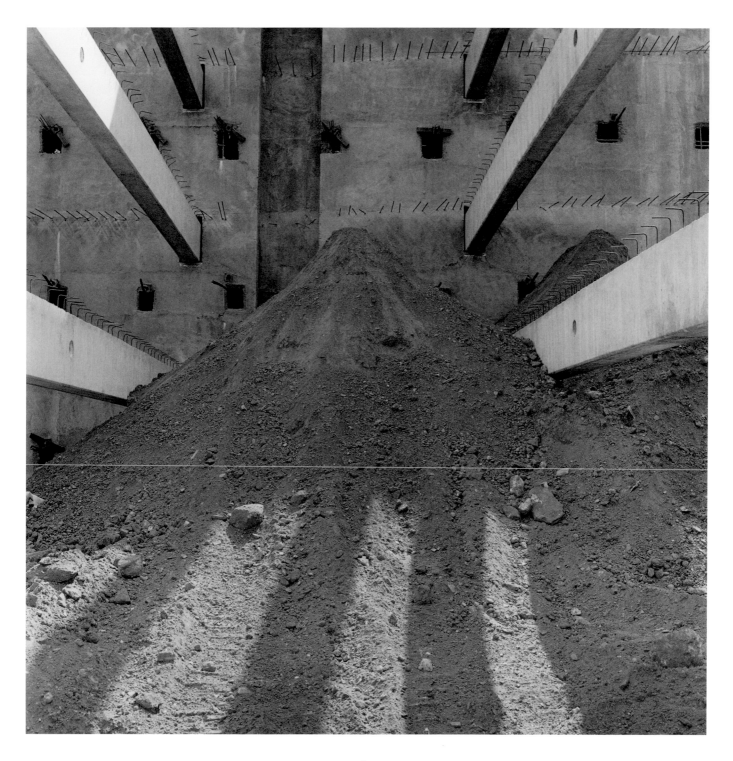

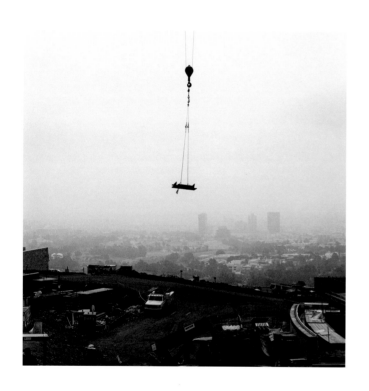

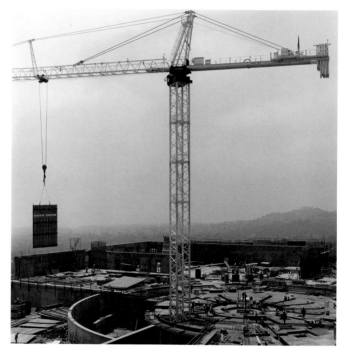

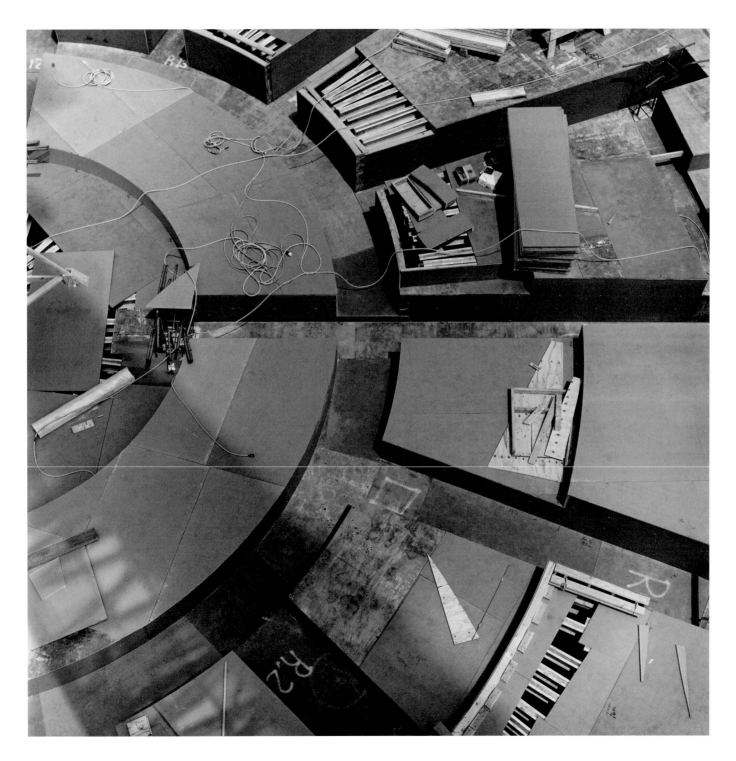

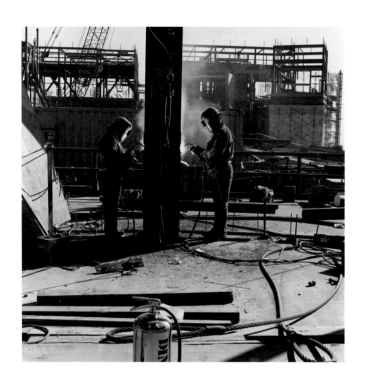 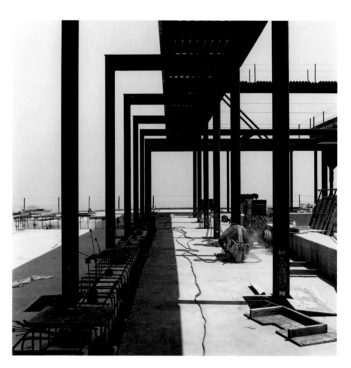

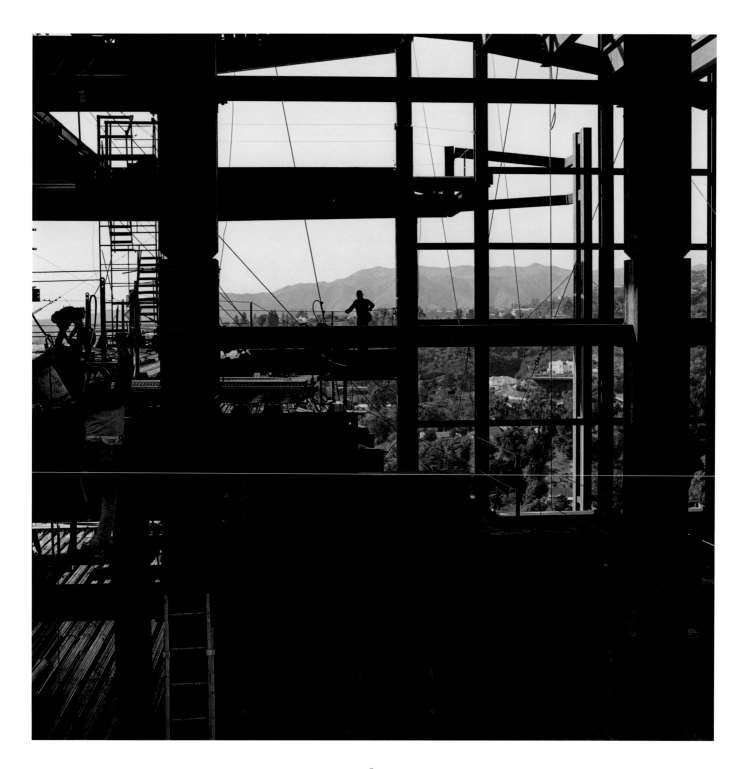

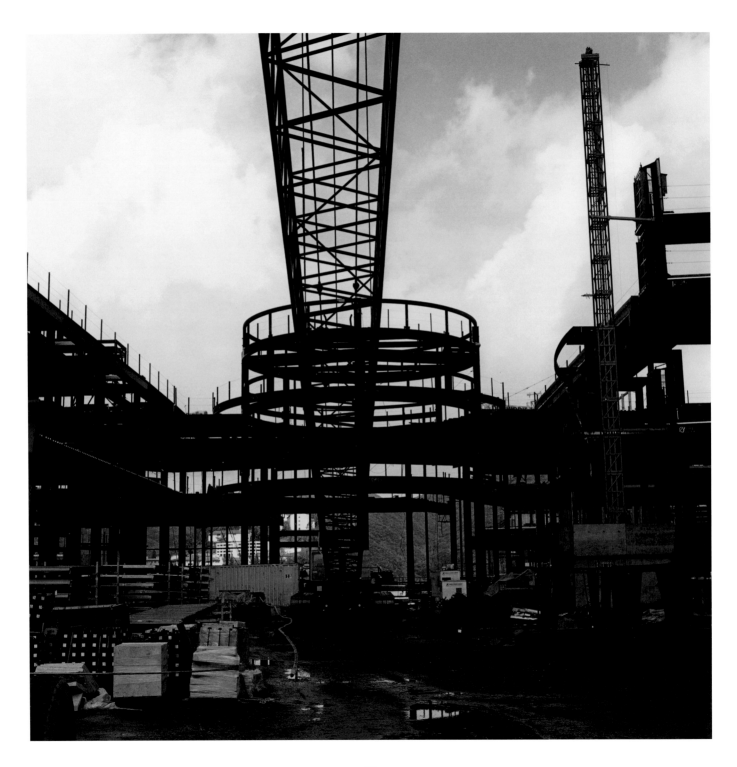

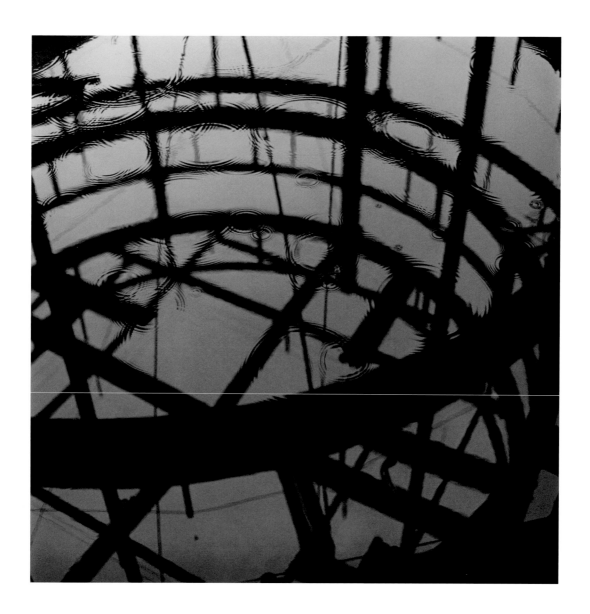

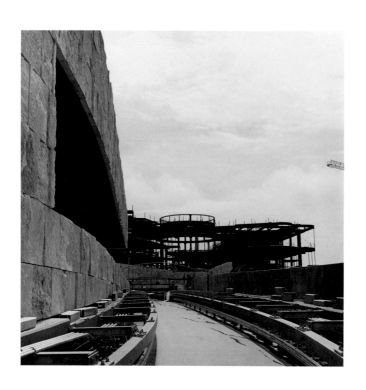

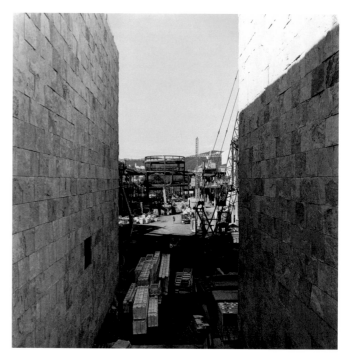

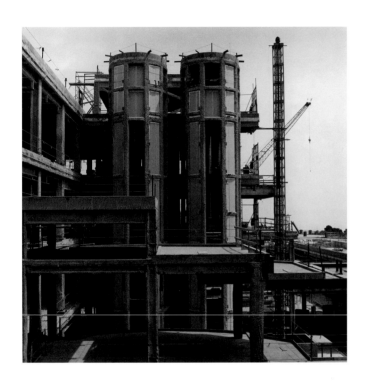

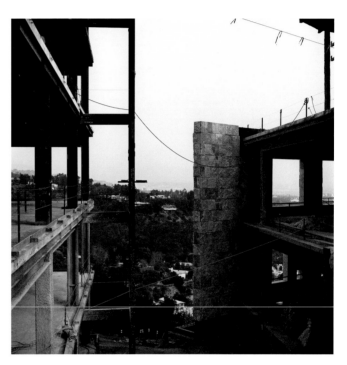

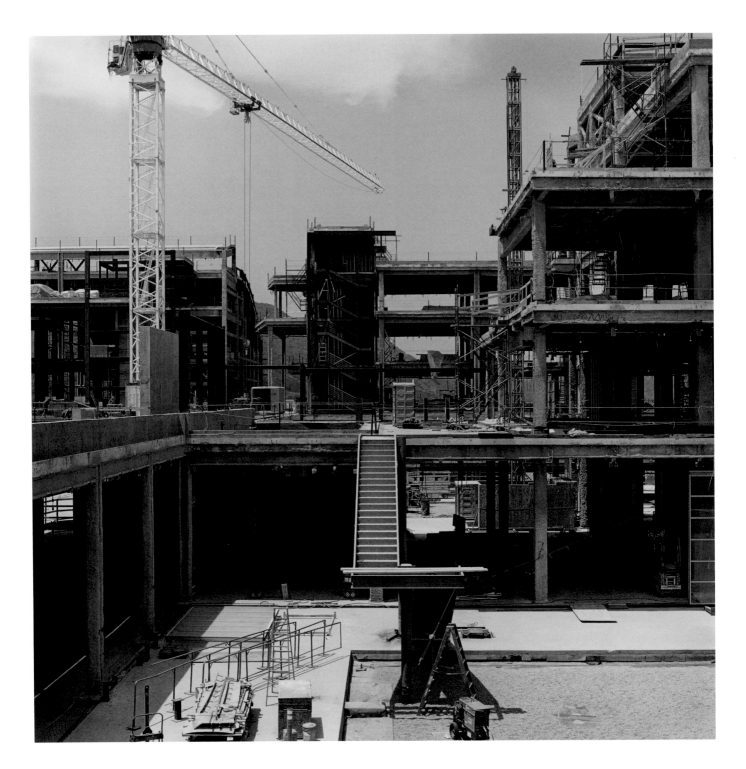

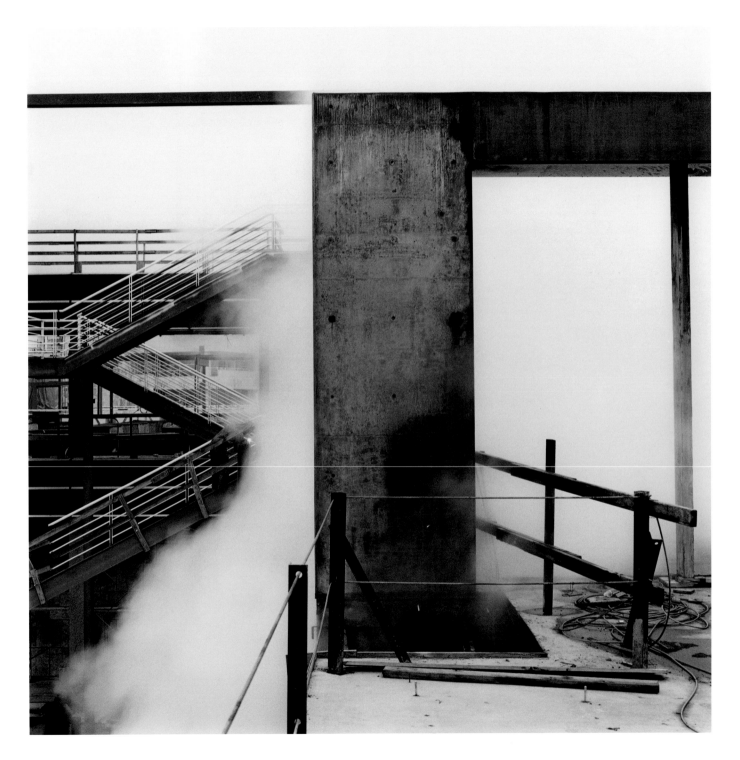

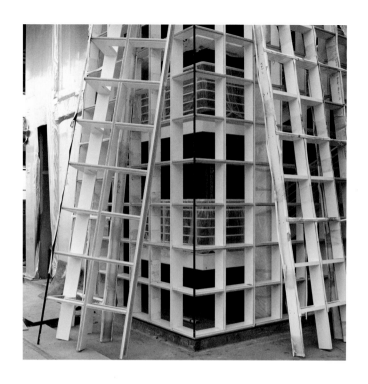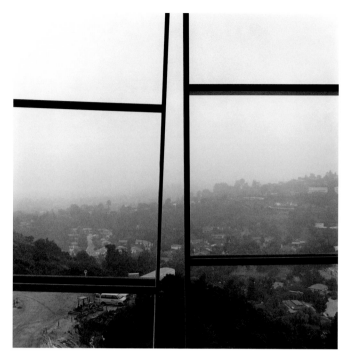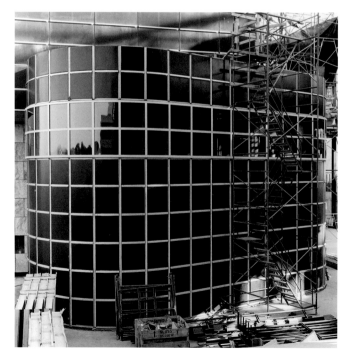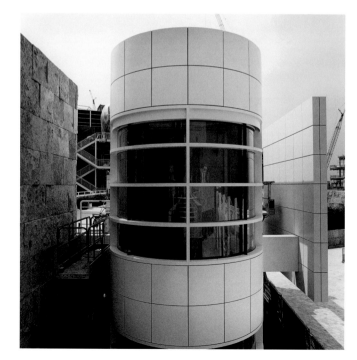

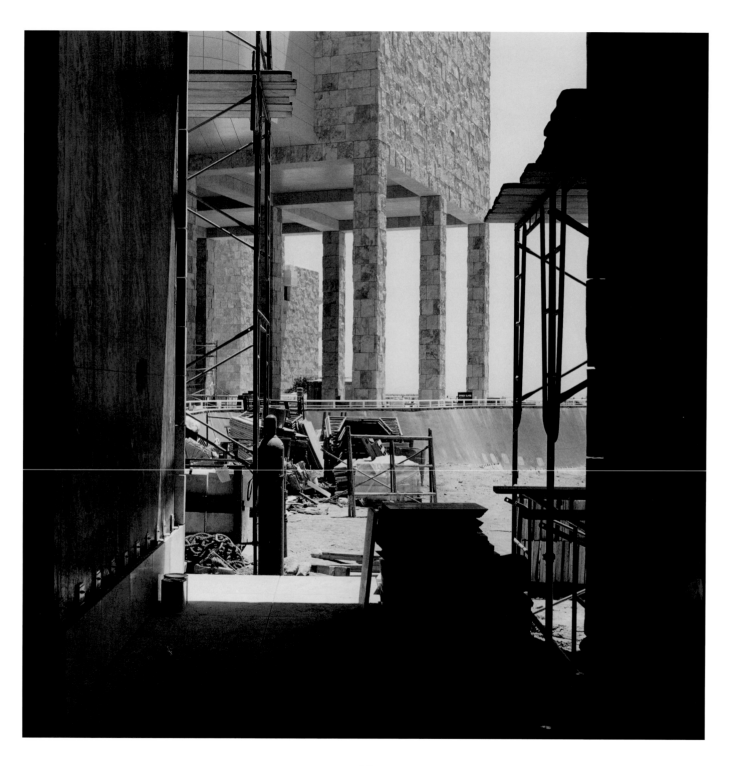

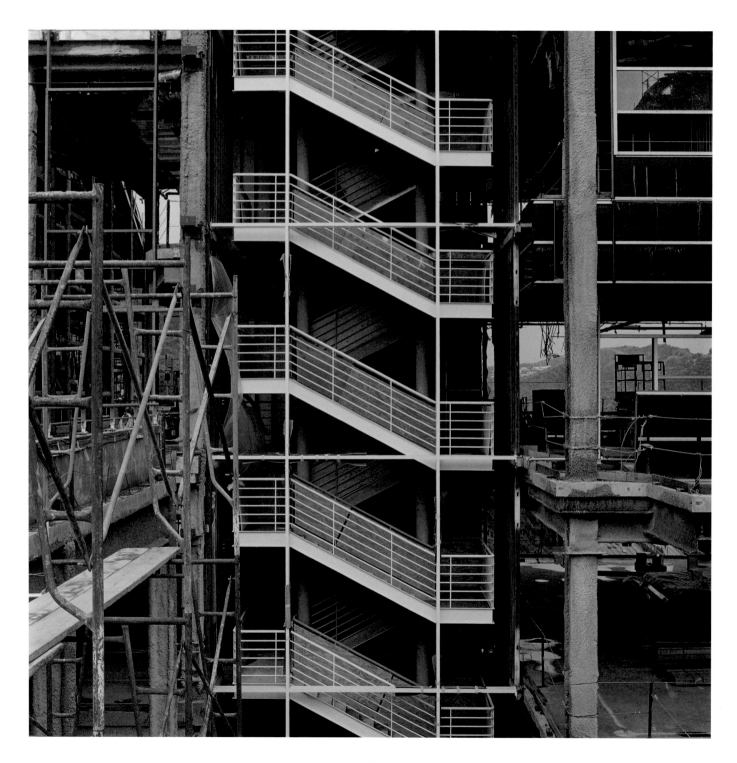

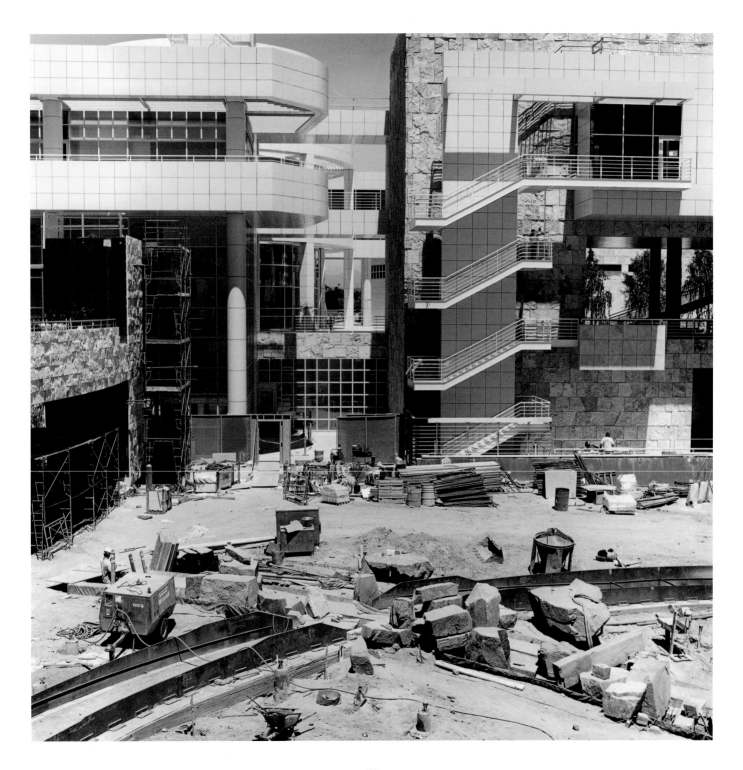

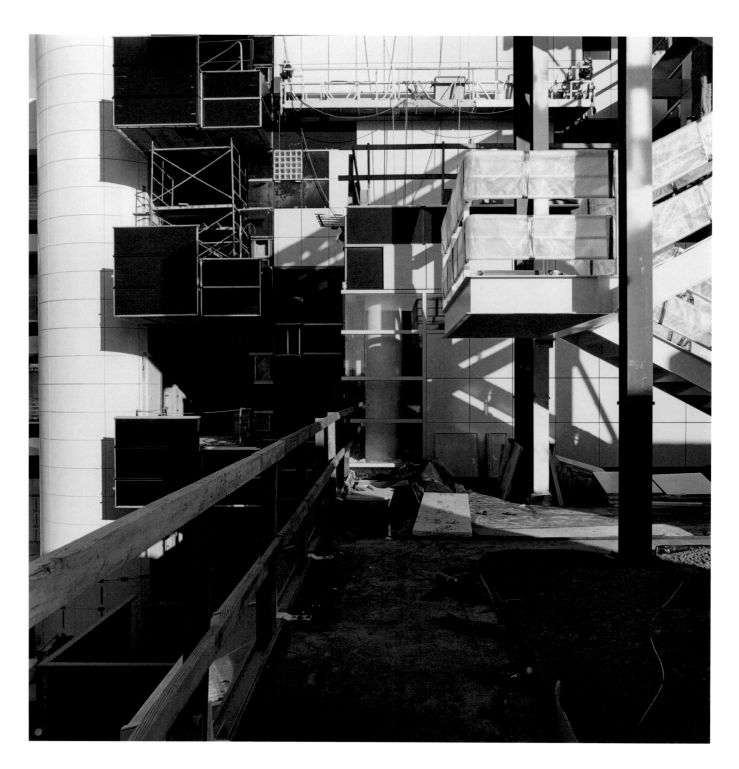

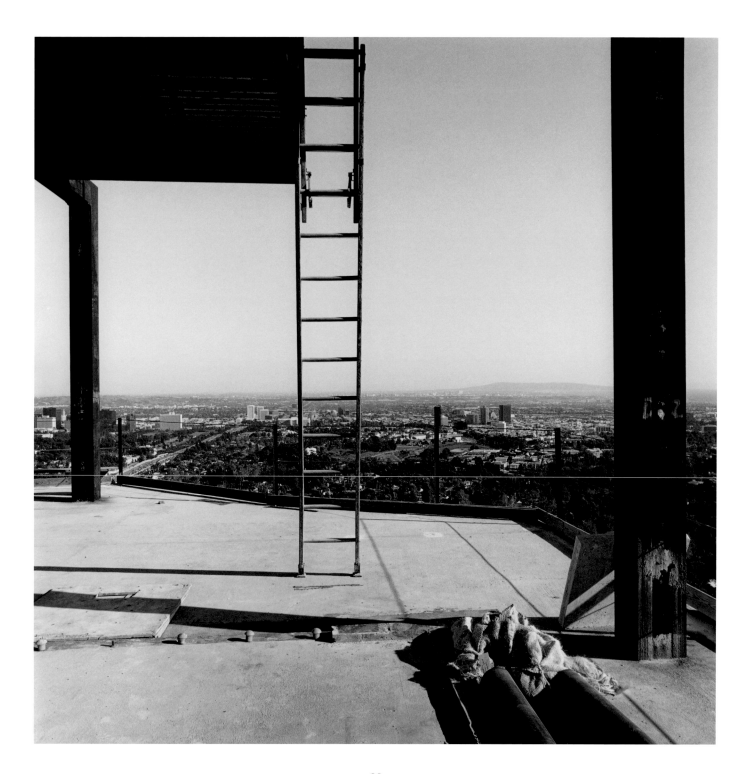

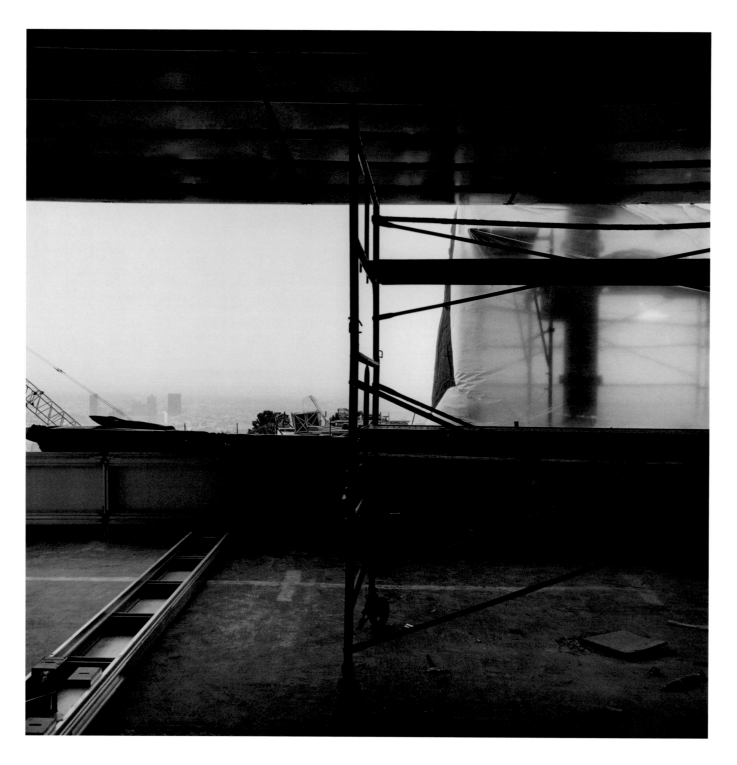

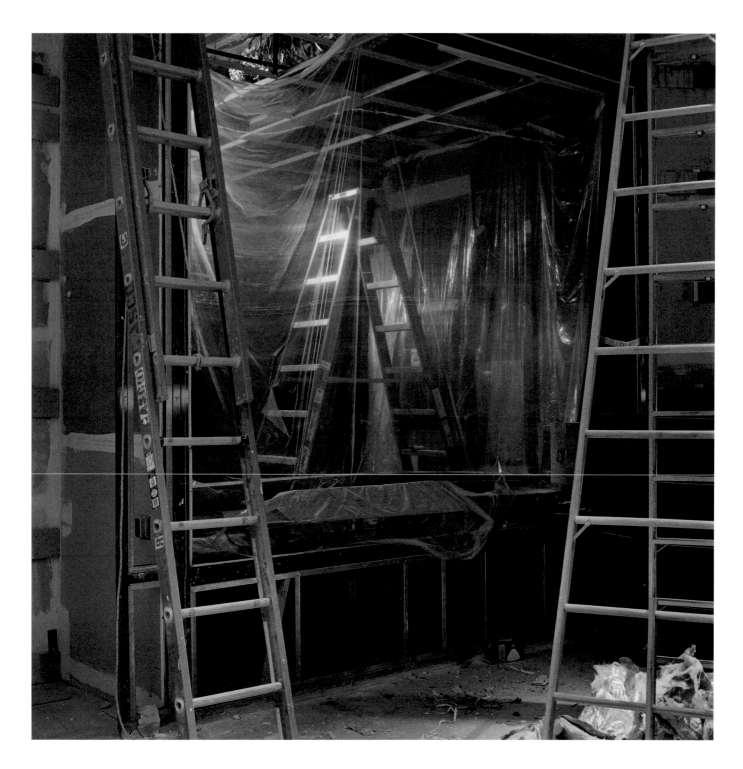

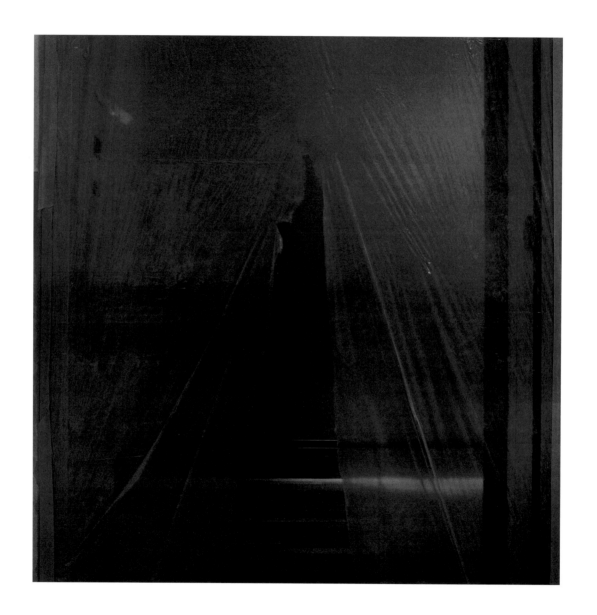

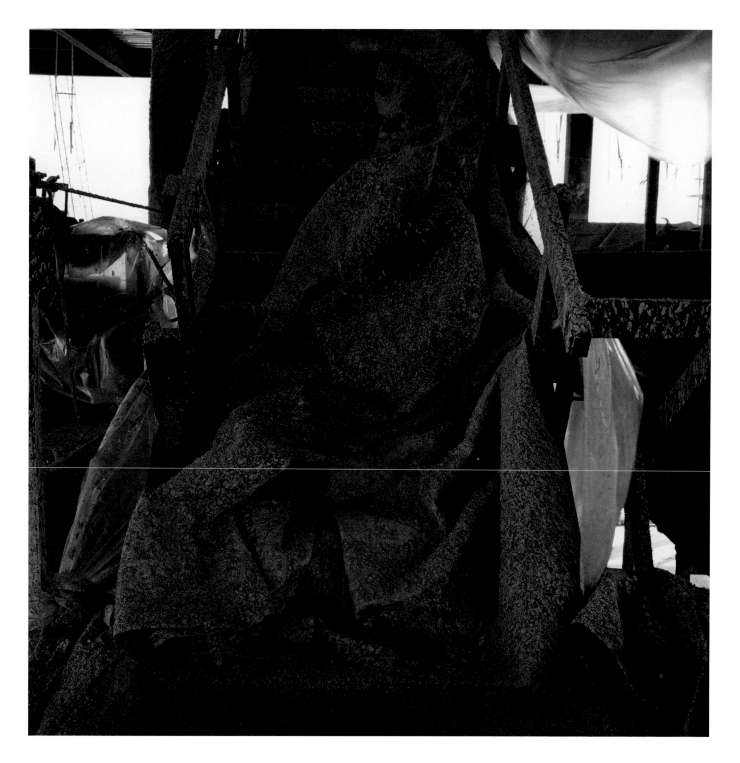

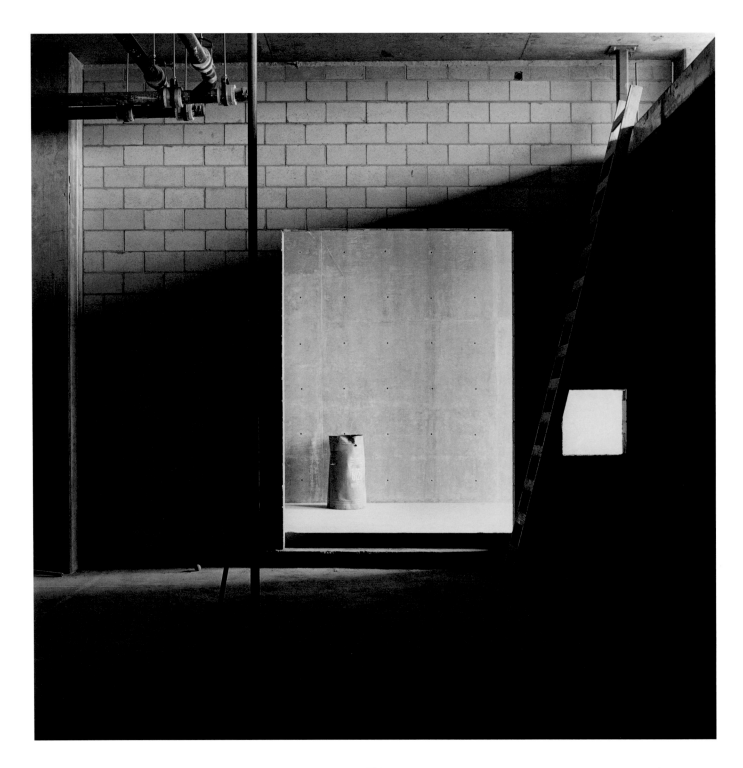

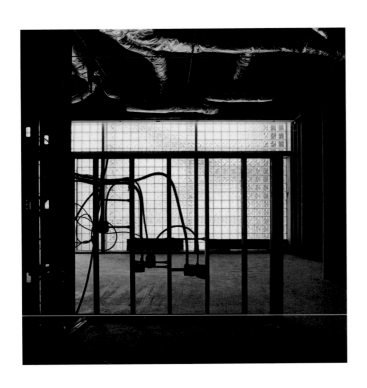 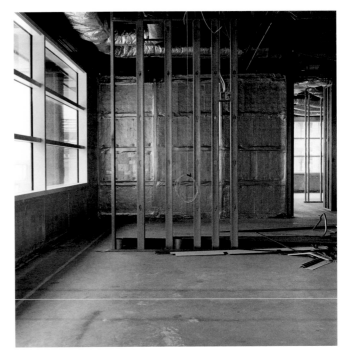

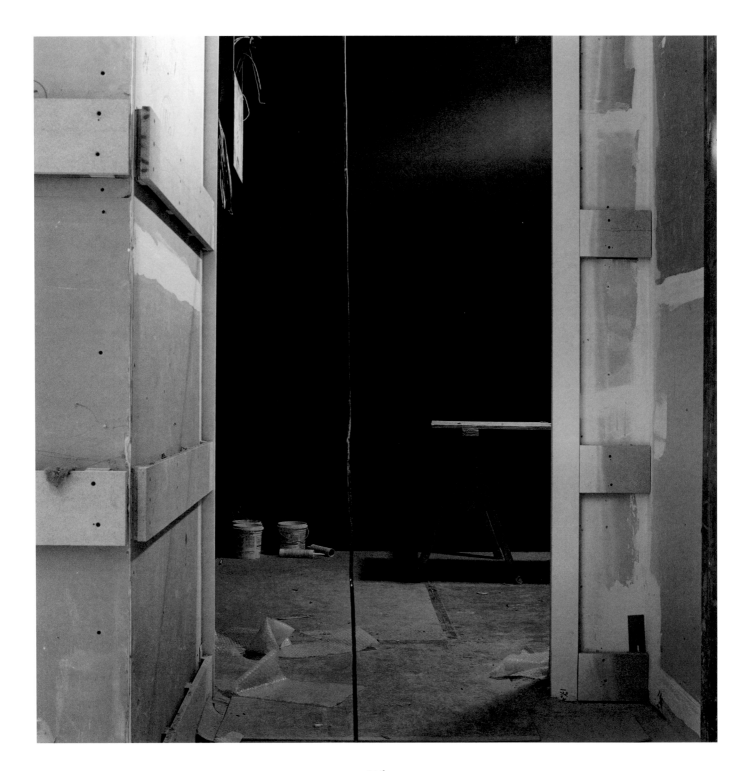

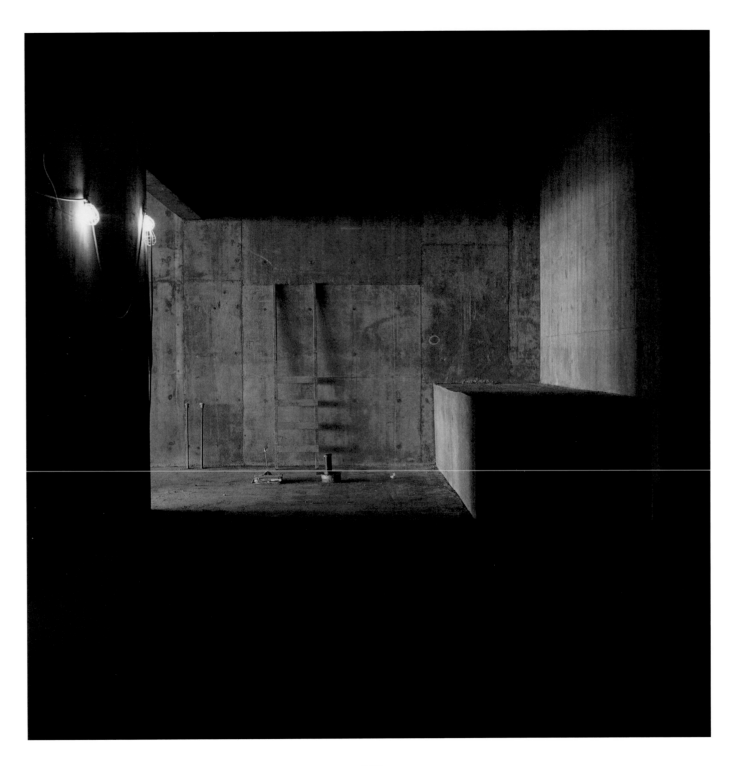

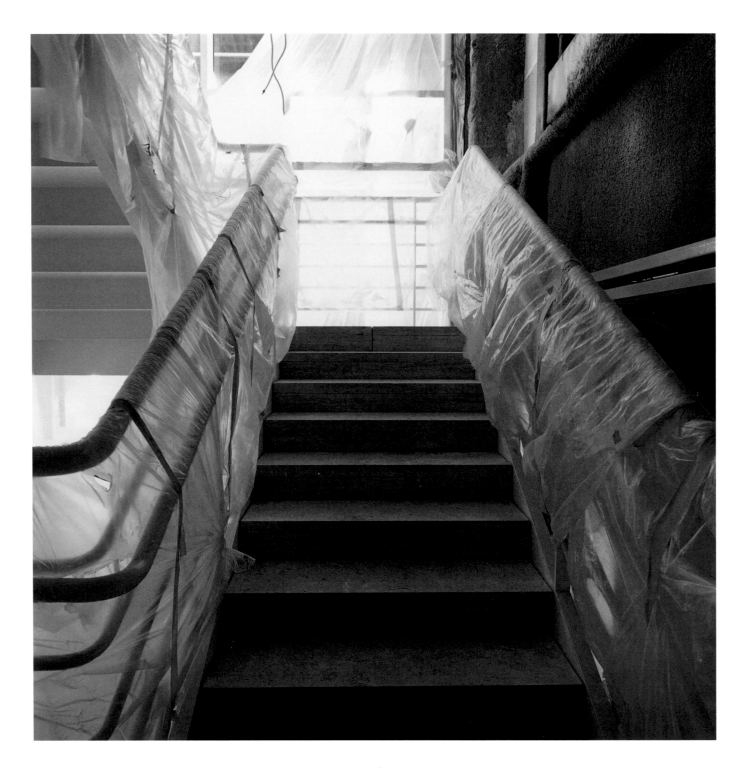

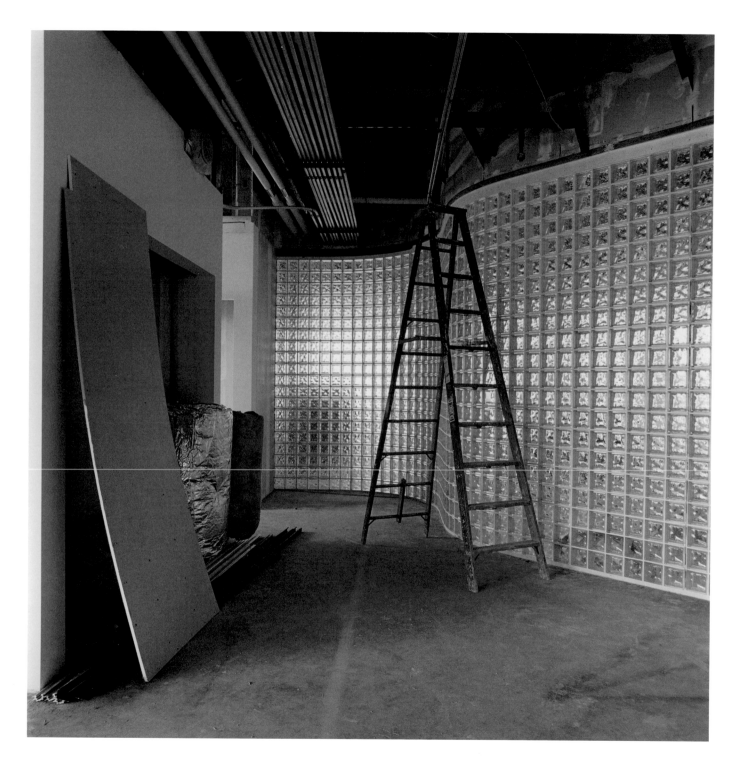

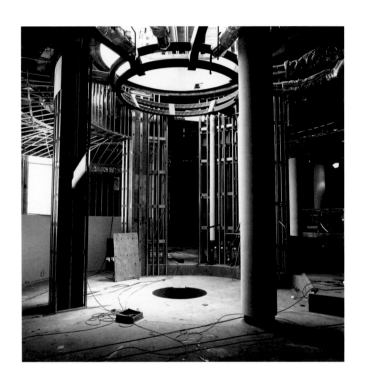
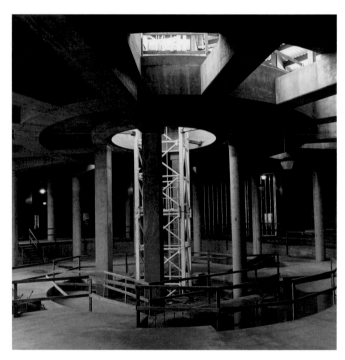

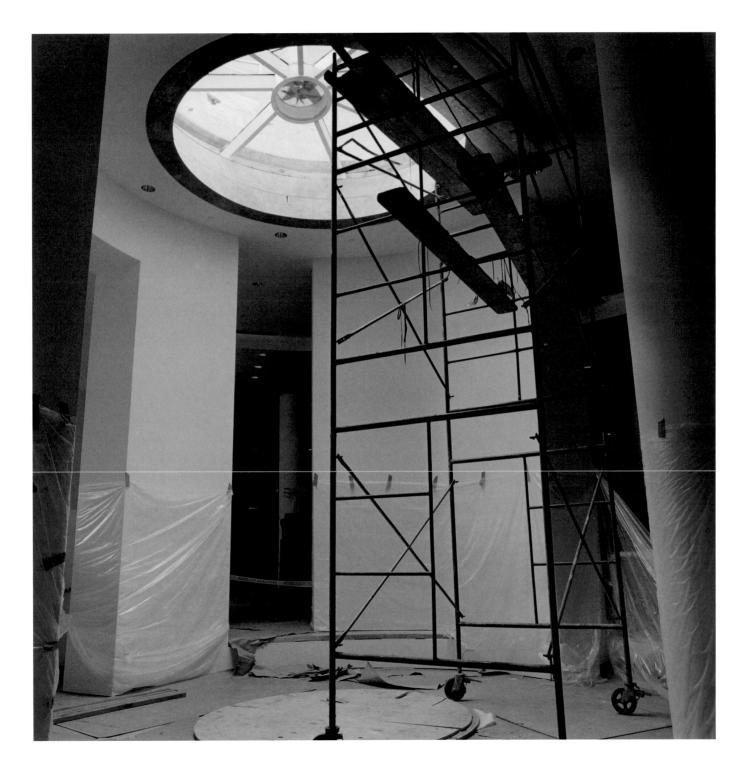

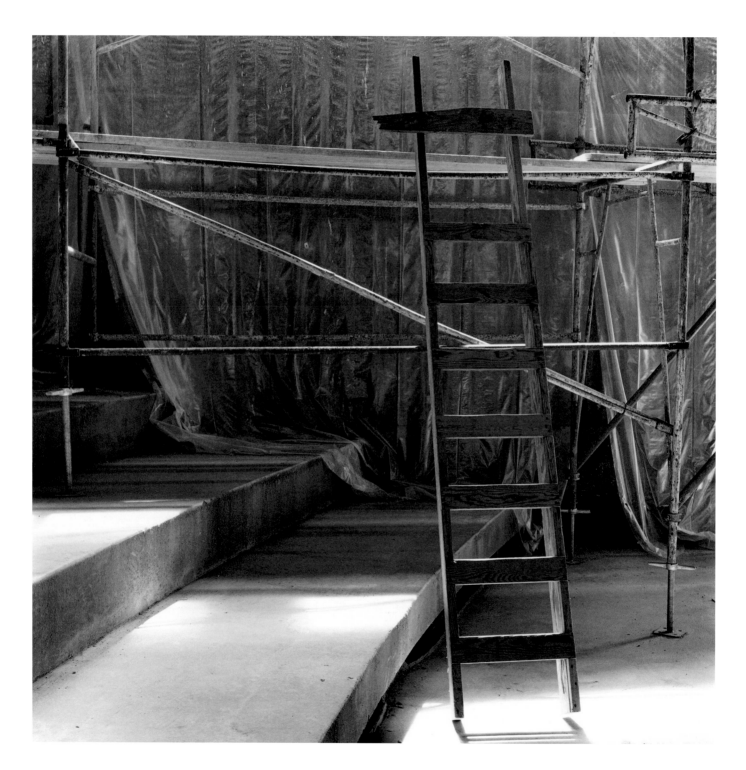

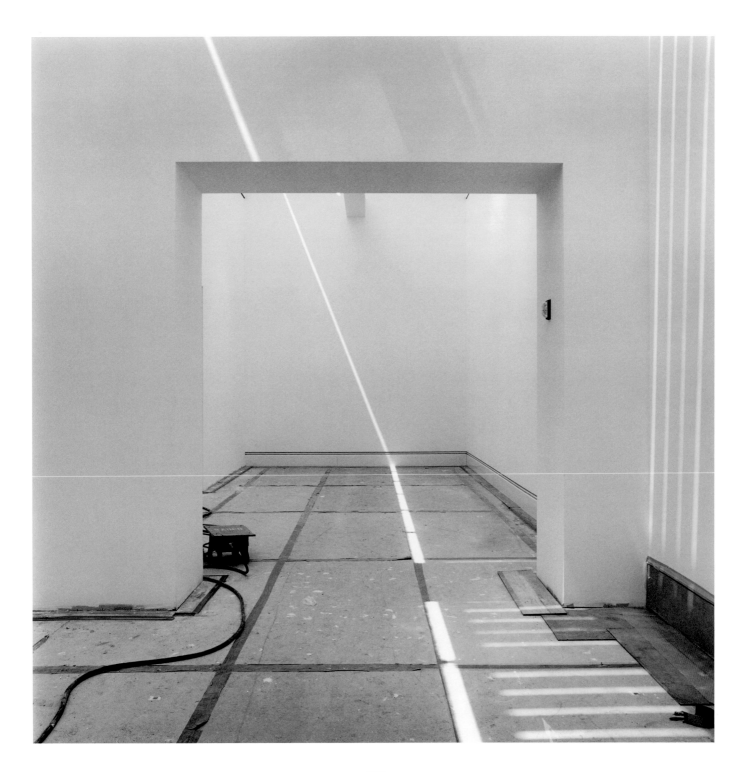

Place

+ + +

TOPOS IS ULTIMATELY ABOUT the transformation of the landscape, as is so strikingly evidenced in this series of photographs of the stone covering the walls and buildings of the Getty Center. The stone, an Italian travertine, is a limestone material that was lifted from some early landscape once covered with water and split in such a way as to reveal fossils, such as leaves and a feather. This compelling idea of a landscape, ancient and displaced, used to transform another features prominently in the last of these portfolio images.

Here a narrative of the transformation of the landscape by the travertine unfolds: the stone awaiting unpacking and installation; being installed onto the buildings; and, finally, appearing as a new landscape. These compositions juxtapose the softness of the earth and sky with the roughness of the stone, contrasting the massive stone in the foreground with the hazy distant views of the horizon and making prominent the edges of the buildings as they touch the landscape and define the place.

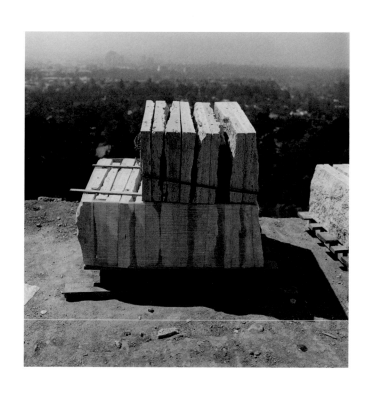

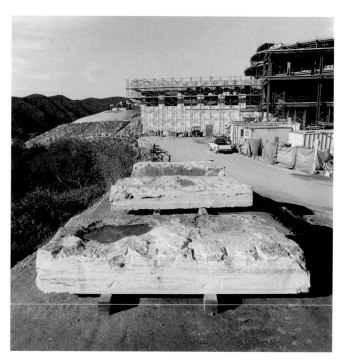

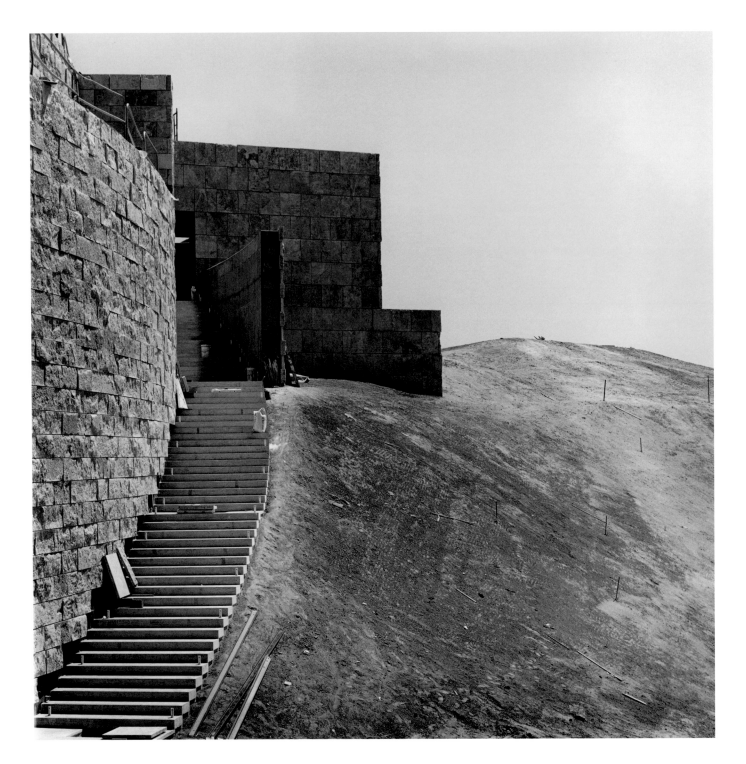

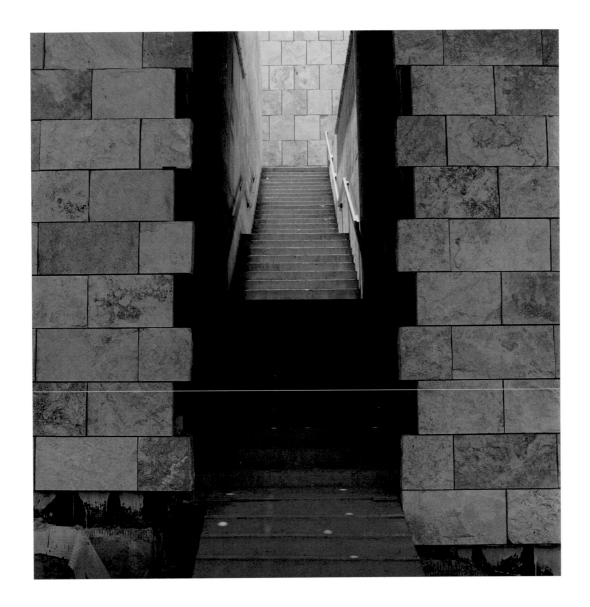

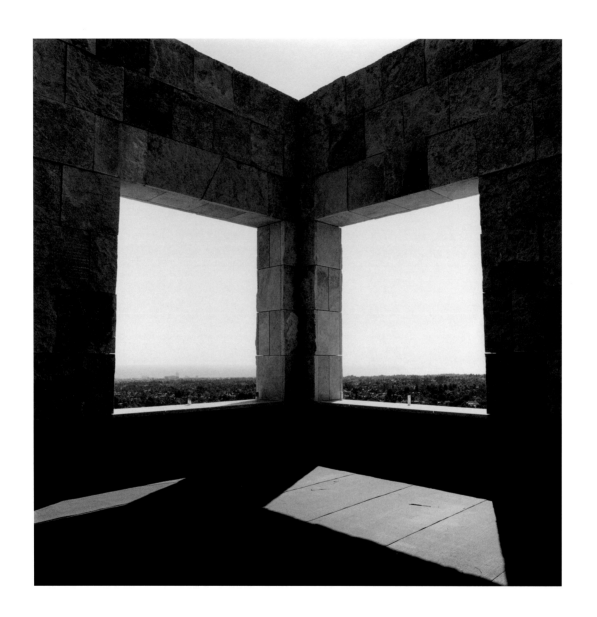

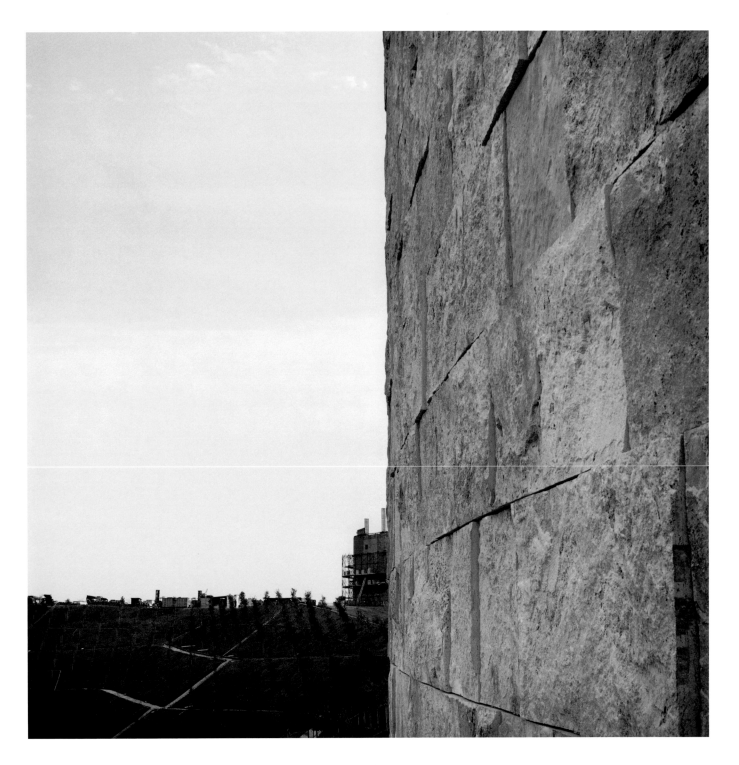

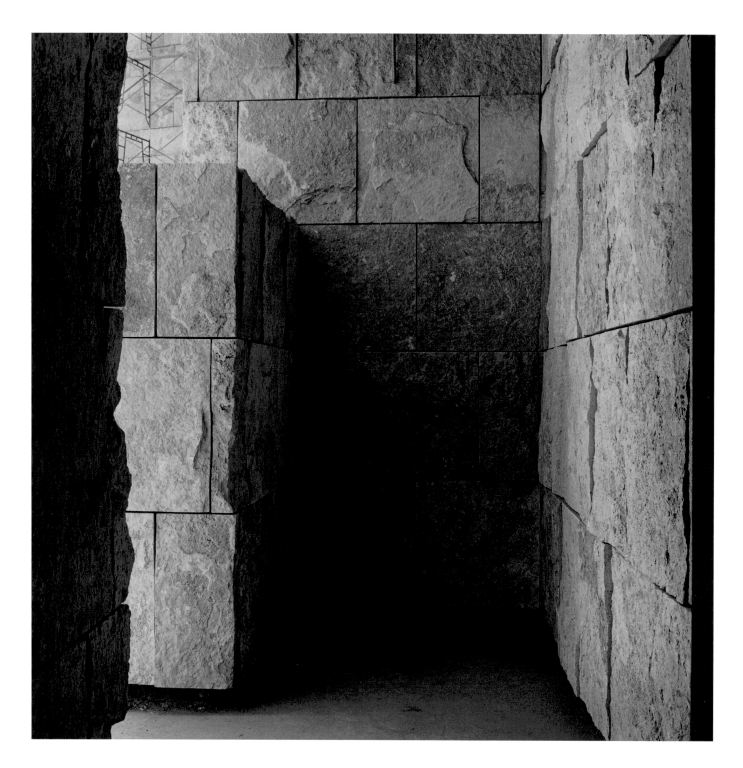

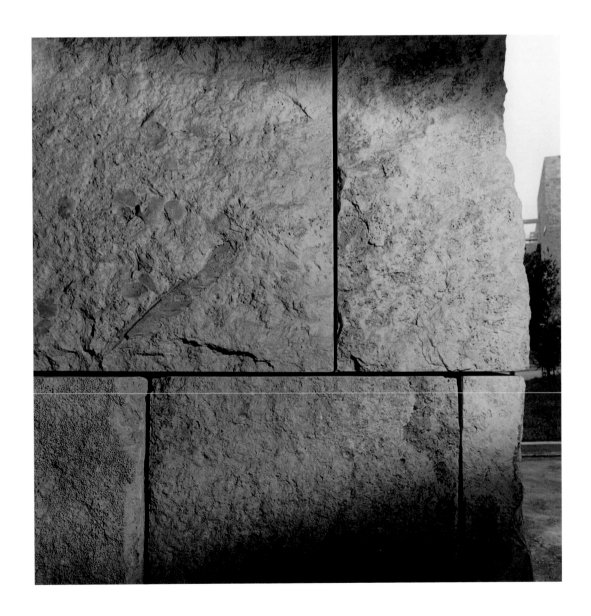

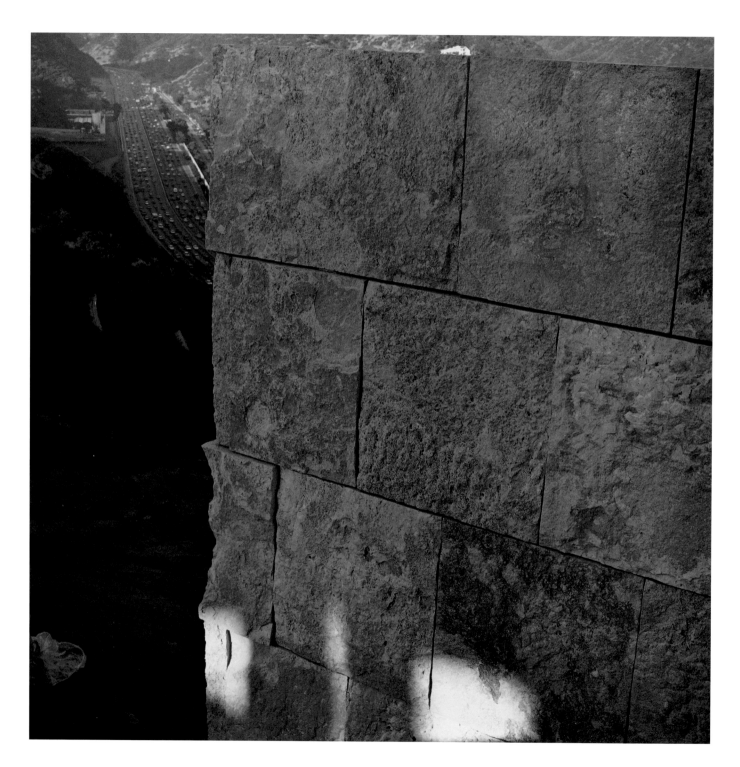

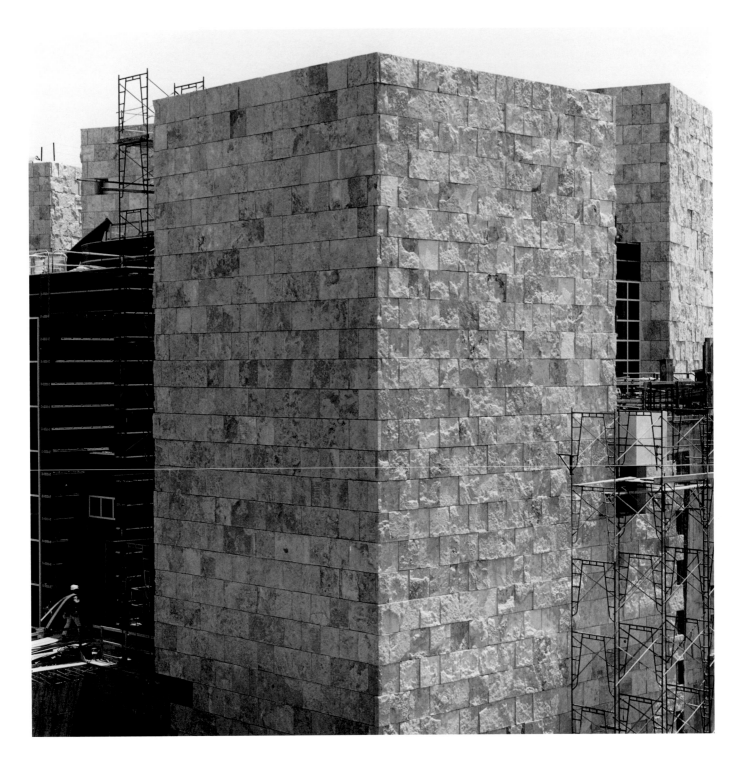

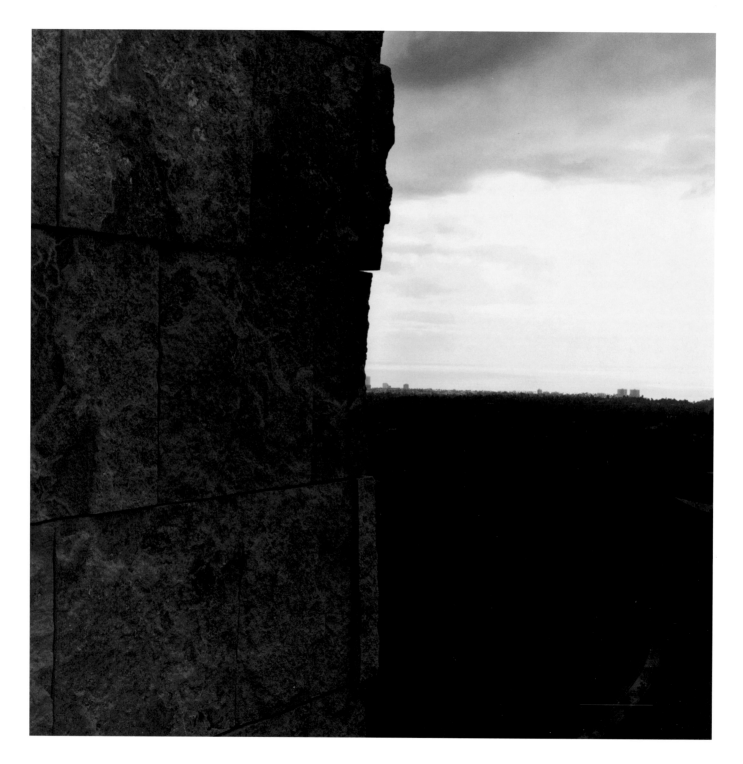

List of Photographs

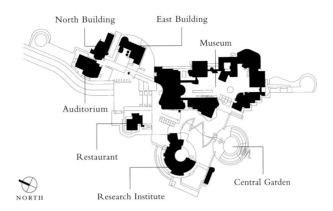

North Building East Building Museum

Auditorium

Restaurant

Research Institute Central Garden

NORTH

The photographs in *Topos* were made in two formats. Those made between 1984 and 1989 are 17 × 14 in. (43.18 × 35.56 cm); those made between 1992 and 1997 are 19.5 in. × 19.5 in. (49.53 × 49.53 cm). The date and accession number of each photograph are listed below. The photographs are all untitled; however, where possible, the directional view and building of the Getty Center are identified. For purposes of this book, directionals are simplified as north (toward Sepulveda Pass), south (toward west Los Angeles), west (toward the Pacific Ocean) and east (toward downtown Los Angeles).